IMAGES
of America

SEATTLE'S
PIONEER SQUARE

Joy Keniston-Longrie,
Foreword by Wes Uhlman

D1595672

ARCADIA
PUBLISHING

Published by Arcadia Publishing
Charleston SC, Chicago IL, Portsmouth NH, San Francisco CA

Printed in the United States of America

Library of Congress Control Number: 2008942876

For all general information contact Arcadia Publishing at:
Telephone 843-853-2070
Fax 843-853-0044
E-mail sales@arcadiapublishing.com
For customer service and orders:
Toll-Free 1-888-313-2665

Visit us on the Internet at www.arcadiapublishing.com

Dedicated to my great-grandfather Clay Lincoln Keniston and great uncle Frank Keniston, who arrived in Seattle in 1884; my grandfather George Keniston; and my dad, Dick Keniston.

CONTENTS

ACKNOWLEDGMENTS

This book would not be possible if not for the original photographers who documented our rich history so well and had the foresight to donate their collections to be properly preserved, archived, and accessible to the public. Special thanks go to Wes Uhlman and Art Skolnik; Sunny Speidel, Dan Trefethen, and Dietrich Sachs, Bill Speidel's Underground Tour; Carolyn Marr and Leonard Garfield, Museum of History and Industry; Joy Werlink, Elaine Miller, and Fred Poyner, Washington State Historical Society; Jodee Fenton, Carol Lo, and Talia Kaye, Seattle Public Library; Brian Kamens, Tacoma Public Library; Jeff Ware, Seattle Municipal Archives; Robert Fisher, Wing Luke Museum; Doris Larsen; Mildred Andrews; Joanne Markert and Layne Alfonso, GeoEngineers, Inc.; and editor Sarah Higginbotham, Arcadia Publishing. Last but certainly not least, a special thank you to my family, Mark, Kelsey, and Amberose Longrie and Lorraine Keniston, for their support throughout this whole process.

The following organizations have been abbreviated within this book:

MOHAI	Museum of History and Industry
UWSC	University of Washington Special Collections
WSHS	Washington State Historical Society
WSU-MASC	Washington State University–Manuscripts, Archives, and Special Collections
SPL	Seattle Public Library

FOREWORD

George Santayana famously said, "Those who cannot remember the past are condemned to repeat it."

Seattleites have always been an audacious bunch. Seattle settlers and pioneers have a rich and unparalleled history, beginning with their first settlement on the windy and unprotected shores of Alki Point off Puget Sound.

They had the audacity to name their new settlement New York Alki, using the Indian word for "by and by." As they were almost blown off the point that first winter, the Denny party moved inland to Elliot Bay and immediately began platting land for sale and settlement.

After a number of contentious relationships with the Native Americans residing there, who understandably did not view their displacement kindly, the city fathers finally reached an accommodation with them. With true audacity, they then promptly named their new town after one of the native chiefs!

The settlers hardily overcame the many frustrations that came with their geographic isolation and almost sole dependence on the lumber industry, and their dreams grew slowly but with great determination.

Then came the Great Fire of 1889. The city literally burned to the ground. While the coals were still smoldering, a large group of citizens met and made the decision to send the then-sizeable sum of $700 previously accumulated for local civic needs to the victims of the Johnstown, Ohio, flood. And they optimistically rebuilt the city with permanent stones and bricks.

In 1897, the famous "Ton of Gold" from the great gold strikes in Alaska arrived via the steamship *Portland* heralding, as the *Seattle Post-Intelligencer* breathlessly proclaimed, "a new era . . . in Seattle." A few Seattle citizens (including the mayor) left for the north to seek their fortunes; many Seattleites stayed home from the goldfields of Alaska and Canada and proceeded to build the city by becoming the suppliers and shopkeepers to miners passing through.

All of these bold and audacious activities occurred in what is now known as Pioneer Square—the 30 blocks of Seattle's birthplace.

This rich and irreplaceable birthplace of Seattle's history almost met its demise in 1970, when city planners considered bowing to "progress" by demolishing most of the buildings to replace them with two large office towers surrounded by vast parking areas.

I was privileged to assist in leading the battle against this destruction of our history and our heritage—perhaps an audacious move for the youngest mayor (34 years old) in Seattle's history. Joined by several undaunted architects and Pioneer Square building owners already engaged in small preservation efforts, we voiced a resounding no to the city plans. An acrimonious fight broke out between most building owners and downtown developers and those of us who believed our history and heritage were at stake. Highly contentious debates centered around what many of them viewed as taking their property rights to develop as they wished. After all, these were "just a bunch of old buildings" having outlived their usefulness. It was time for the new!

The battle was finally settled on a split city council vote to adopt my proposal to form a Pioneer Square Historic Preservation District, one of the first in the country. And, with a few skirmishes and incursions by preservation foes over the ensuing years, the final battle has been won. And the rest is history!

Seattle will never forget its history. Pioneer Square is now a special place in most Seattle citizens' hearts.

—Wes Uhlman
former mayor of Seattle (1970–1977)

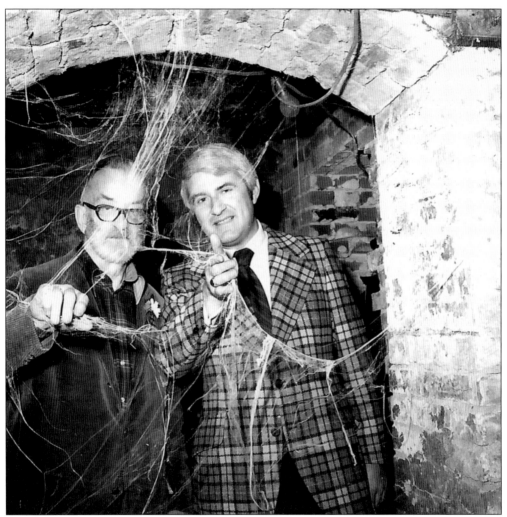

UHLMAN AND SPEIDEL. Wes Uhlman, mayor of Seattle from 1970 to 1977 (left), and Bill Speidel, founder of Seattle's Underground Tour, are pictured underground in an areaway under the sidewalks of Pioneer Square around 1975. These two men made history when they worked with a coalition of public and private interests to save historic Pioneer Square from the wrecking ball. (Bill Speidel's Underground Tour.)

INTRODUCTION

The place known as Seattle's Pioneer Square has been shaped by earthquakes, landslides, floods, glaciers, and people. The Pioneer Square–Skid Road Historic District has distinct boundaries; however, the story and events that shape the place known as Pioneer Square have less definition. The images in this book illustrate the activities and events that took place in the history of this area approximately bound today by Qwest and Safeco Fields to the south, University Street to the north, I-5 to the east, and Elliott Bay to the west. The character of the area has been strongly influenced by the people who have lived and worked in Seattle's Pioneer Square, which in the beginning reflected the era of immigration: a predominately single-male population. The people who live and work in this area have always been diverse, but the author has found that the historical images available do not always reflect this diversity. Ironically, the single most important place and icon that best reflects Pioneer Square, via events, people, its character, and dramatic change, is in fact not a square at all—it is a relatively small, triangle-shaped public space known as Pioneer Place Park. An unresolved platting dispute between founders Dr. David "Doc" Maynard and Arthur Denny dating back to 1853 actually preserved this wide spot in the road as the place and the legacy we know today. This triangular parcel of land has been the heart and soul of Seattle. This historically significant place is where the Duwamish/Suquamish tribe drummed the life rhythms and heartbeat of the First People thousands of years prior to the appearance of the first explorers. This place has witnessed tremendous change, but some of the themes remain the same; today, the hustle and bustle of people connects the past to the present and the future with the same heartbeat of life, as millions of people pass through en route to work, home, businesses, or as visitors to the area, drawn to this unique place, Seattle's oldest neighborhood and the birthplace of downtown: Seattle's Pioneer Square.

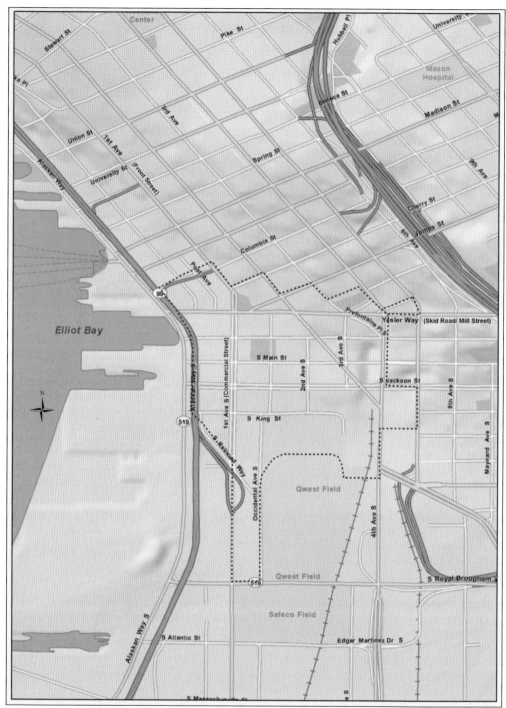

PIONEER SQUARE STREET GRID. The map above shows Pioneer Square's 2009 street grid. The actual area on the National Register of Historic Places is enclosed within the dotted outline. The map shows the streets that played an important role in Seattle's early history. (Joanne Markert, GeoEngineers, Inc.)

One

JIJILAETCH
LITTLE CROSSING-OVER PLACE

The First People's creation story tells of chaotic change—earthquakes, volcanoes, landslides, floods, and glaciers. Ice over a mile thick covered Seattle during the last ice age, 16,000 years ago, when the Vashon Glacier expanded from Canada to carve out the *Whulge* (Salish for Puget Sound). *Dookweebathl*, the "Changer," brought order to things: the marine, estuarine, and fresh waters created pristine habitats for an abundance of fish, shellfish, birds, and wildlife, including the regional icons of salmon, orca whales, eagles, and elk.

Native American people, known as *Dkh' Dus Absch* (Duwamish), "People of the Inside;" *Xacuabsh*, "People of the Large Lake;" and *d'suq'wub* (Suquamish), "People of the Clear Salt Water," settled along the shorelines, including the Whulge, and many lakes and rivers. Native Americans have lived here for nearly 10,000 years. They carved canoes from tall cedar trees that grew profusely along the shores of the Whulge and used cedar planks to build longhouses to live in.

The Little Crossing Over Place, *Jijilaetch* (Pioneer Square today), has long been a culturally significant place to Native American people. Several great cedar longhouses, *Khwaac' al' al*, were located here and were inhabited by multiple extended families. At that time, Jijilaetch was a small island surrounded by marine waters. When the tide was low, a "little crossing over place" was exposed where a person could walk from Jijilaetch to the mainland along a narrow rocky beach flanked by steep banks. An extensive protected lagoon became mud flats at low tide. This place has been and continues to be very important for the Duwamish, Suquamish, and other tribes.

Chief Sealth, whom Seattle was named after, was just a young boy when he witnessed Capt. George Vancouver enter Bainbridge Island Harbor in 1792 on the sailing ship HMS *Discovery*. Years later, Chief Sealth befriended the Denny party and encouraged Suquamish/Duwamish people to help the new settlers adapt to their surroundings. Native American people played an important role in this place once called Jijilaetch and today known as Pioneer Square.

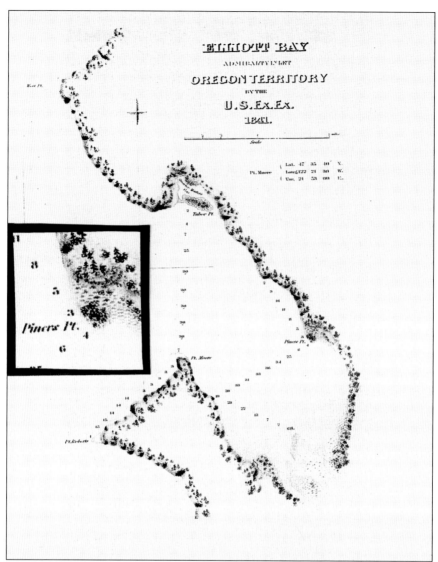

DUWAMISH BAY. The First People's presence has been carbon dated to 10,000 years ago. Their creation story is of chaotic change—the earth shifting, rivers flowing two ways, and brutal cold—until *Dookweebathl*, the "Changer," brought order to things. It took another 1,000 years for the climate to stabilize, resulting in the appearance of fish and forests. In the 1850s, thirteen prominent villages populated by approximately 500 Duwamish Indians were located around Duwamish Bay, now known as Elliott Bay. Thousands more Duwamish lived in their traditional watershed homelands, which extended from Shilsho Bay to Renton. This 1841 map prepared by U.S. Navy captain Charles Wilkes illustrates the coastline in the 1840s. This area was shaped by glaciers, earthquakes, rivers, tides, and landslides, creating a large natural bay with a sheltered tideland at the mouth of the Duwamish River. Tidelands provided an excellent habitat for a multitude of upland and aquatic plants, birds, animals, shellfish, and fish, which the Duwamish and Suquamish people relied upon for their daily traditional lifestyle. Jijilaetch, the Little Crossing Over Place (named "Piners Pt." on this map and the current location of Pioneer Square), was originally a small island occupied by Duwamish people with longhouses built on this location. (Washington State Archives.)

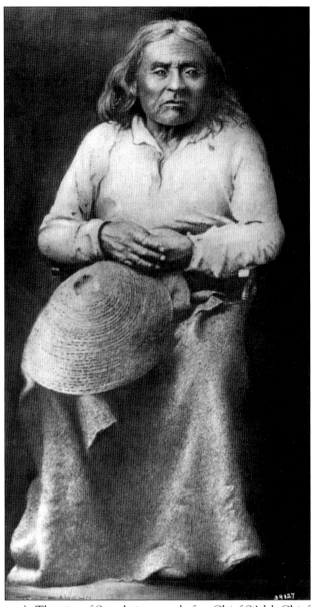

CHIEF SI'AHL (SEALTH). The city of Seattle is named after Chief Si'ahl. Chief Si'ahl was born in approximately 1780. His father, Shweabe, was *d'suq'wub* (Suquamish), and his mother, Sholeetsa, was *Dkh' Duw' Absh* (Duwamish). Si'ahl saw tremendous change during his lifetime. He was just a young boy in 1792 when Britain's Capt. George Vancouver anchored off the shore of a *Dkh' Duw' Absh* summer village near today's Bainbridge Island. Si'ahl witnessed first-hand the devastating results of communicable disease epidemics, including small pox, measles, syphilis, and influenza brought by Europeans, which killed over 30 percent of the Native American population. As chief, a position inherited from his maternal uncle, Si'ahl built strong alliances with six tribes in the central Puget Sound area and with the new settlers. Si'ahl helped the Denny party through the first year at Alki in 1851. He befriended Doc Maynard and helped him select Jijilaetch for his homestead in 1852. Si'ahl was a signatory to the Treaty of Point Elliott in 1855. Si'ahl died in 1866 at the Port Madison Indian Reservation on Agate Pass. (WSHS, 1943.42.34127.)

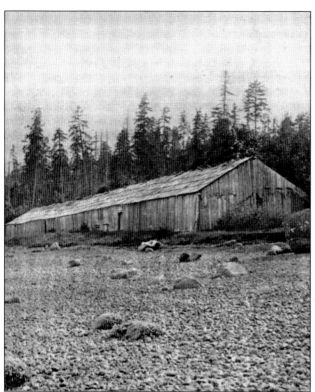

CEDAR LONGHOUSES. The Duwamish/Suquamish people built several cedar plank longhouses at Jijilaetch. The Jijilaetch longhouses were occupied by several extended families during the winter months but were abandoned in the first half of the 19th century, possibly due to epidemics that ravaged the local population after European explorers and traders came to the area in the 1800s. (Whitman College.)

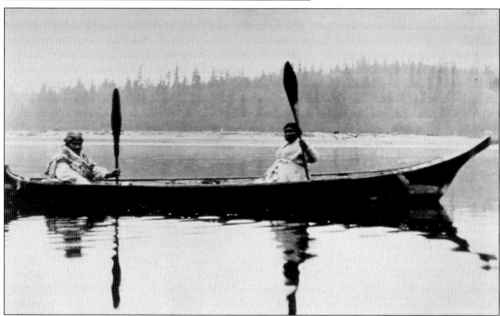

CEDAR CANOES. Cedar trees, which grew profusely along the shores of the Whulge, provided housing, clothing, and transportation for the Duwamish/Suquamish tribes. Canoes carved from a single cedar log provided the primary mode of transportation for the central Coastal Salish people. Canoes also provided a means for fishing and trade as well as maintaining social connections to other tribes in the area. (Seattle Municipal Archives 101702.)

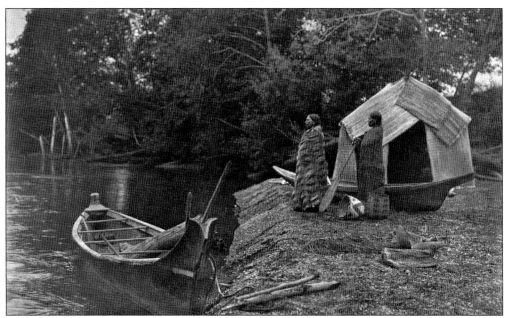

SEASONAL CAMPS. Seasonally, the Duwamish/Suquamish people traveled to other locations to gather roots and berries and fish or hunt. Shelter was provided by poles covered with cattail matting. Cedar bark was used for hats and shawls, as can be seen at this summer fishing camp. Salmon was a dietary mainstay, along with shellfish, elk, bear, deer, duck, rabbits, sprouts, roots, berries, and nuts. (WSHS, Curtis #9.)

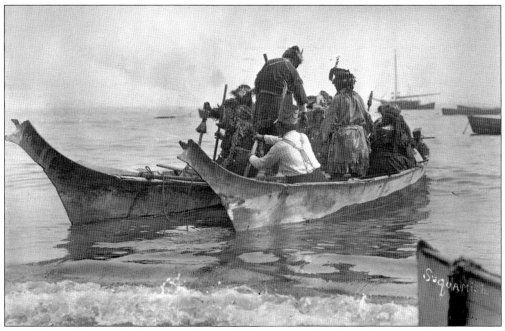

INTER-TRIBAL TRAVEL. Cedar canoes also provided transportation for visiting other tribes, sometimes located far away. This image is of two Suquamish canoes landing for a potlatch. Potlatches are a tradition of giving and practicing spiritual beliefs while sharing food, stories, songs, and dancing, connecting the past to the future. (UWSC, NA1954.)

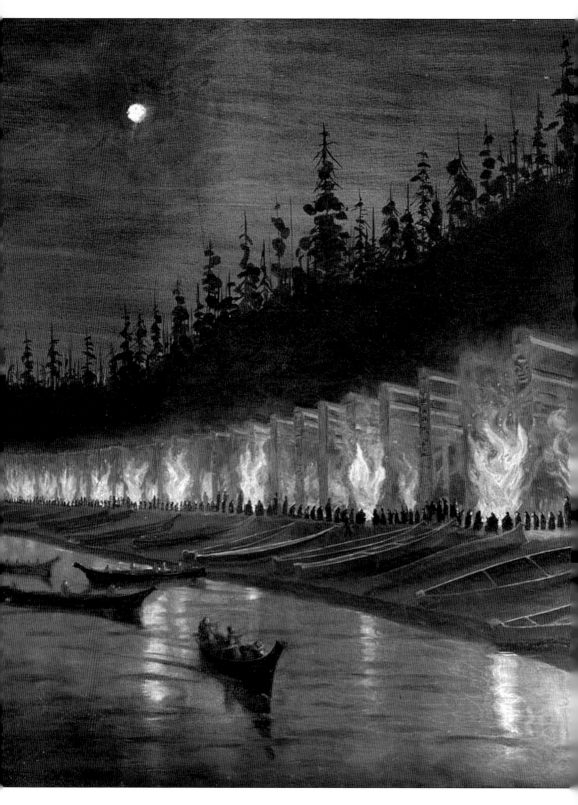

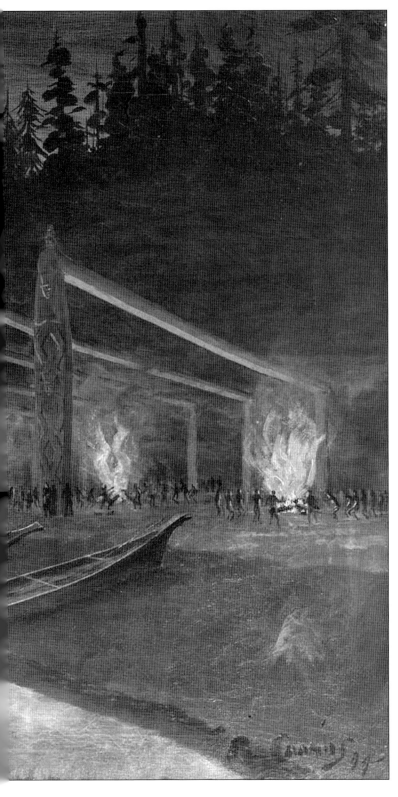

OLD MAN HOUSE POTLATCH. Rafael Coombs's painting of the Suquamish Old Man House (the longest at 1,000 feet and oldest at more than 2,000 years in the region) illustrates a Suquamish/Duwamish potlatch hosted by Chief Si'ahl and Chief Kitsap. Canoes transport tribal people to the shores of what is now known as the Agate Passage and the Kitsap Peninsula. Bright campfires with singers and dancers can be seen in the shadows of the old-growth forest on the shore. The potlatch provides an opportunity to celebrate special occasions and to practice spiritual beliefs. Gift giving and oral history are important traditions of the Duwamish/ Suquamish heritage. Songs and dances help pass ancestral stories from generation to generation. The traditional instrument of the Duwamish/ Suquamish is the drum; the drumbeat reflects life rhythms and is considered the heartbeat of the First People. (WSHS 1898.1.1.)

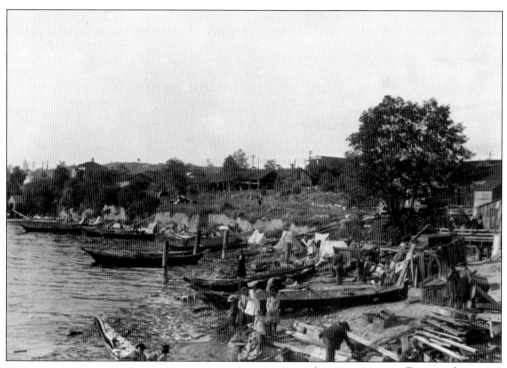

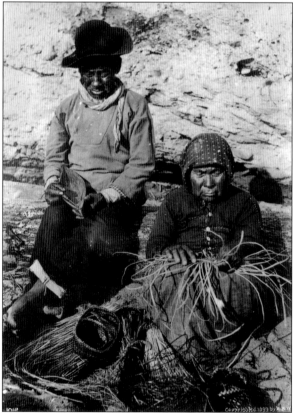

ACCULTURATION. Despite the fact that Chief Sealth helped the new settlers when they arrived in 1851, regulations were soon made prohibiting Native Americans from living in the new city. The native encampment above on the shores of Elliott Bay in the late 1800s symbolizes the disenfranchisement and marginalization of a people. The Native Americans who survived the epidemics were forced to acculturate to survive, losing their language, cultural heritage, and traditional way of life. Basket weaving from materials gathered locally was a skill developed and passed from generation to generation. Traditionally, baskets were essential for use in daily life. At left, a couple is weaving baskets and carving miniature canoes to sell at the local market, no longer able to survive via traditional means. These skills were nearly lost forever. (UWSC NA698; UWSC NA1377.)

Two

SKID ROAD

Dr. David "Doc" Maynard, the "Man Who Invented Seattle," accompanied by Chief Sealth (Seattle's namesake), selected a small island now known as Pioneer Square on the sheltered side of Elliott Bay to homestead. Arthur Denny and other founders also recognized the value of the sheltered bay and moved from Alki shortly before Maynard arrived. The founders saw the importance this geographic location held: it had deep water at a central location on Puget Sound near major rivers and the Cascade Mountains, along with an abundance of natural resources. They envisioned the opportunity for significant economic, social, and political influence this location afforded their new city.

Maynard's Point, the new settlement, was also called Piner's Point and Denny's Island and is now known as Pioneer Square. At high tide, it was an 8-acre island; during low tide, there was a land bridge to the mainland surrounded by steep clay banks covered with evergreen trees. This was the same location that the Duwamish had previously occupied with several traditional longhouses and called Jijilaetch, a name symbolic of the many changes this place had and would see.

Seattle's founders brought a vision of civilization that included businesses, people, and industry, all located on nice flat land. Seattle's urban founders did not waste time; they immediately began clearing timber from the land and moving dirt from Seattle's seven hills to better meet their needs and vision of how their new city should work. Doc Maynard successfully lured Henry Yesler and his steam-powered sawmill to Pioneer Square. Yesler's Mill, the first steam-powered sawmill on Puget Sound, was situated at the end of Skid Road on Elliott Bay. It was the first industry in the area and played a significant economic, environmental, social, and political role in the building of the city. As time passed, more newcomers were lured to the emerald city. Population steadily grew over the next few decades from 302 in 1860, to 1,100 in the 1870s, and to 3,500 in 1880. Seattle grew from a single log cabin in 1852 to a frontier town in the 1870s and evolved into a city of 42,837 in 1890.

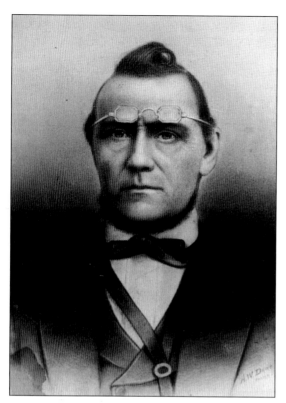

MAYNARD AND DENNY. Traveling via wagon train from Ohio to California, Dr. David Swinson "Doc" Maynard (left) treated the Broshears party, which was suffering from cholera, fell in love with Catherine Broshears, changed travel plans, and went north. In Olympia, he befriended Chief Sealth, who showed him Jijilaetch, which Maynard choose to homestead. Maynard named Seattle after his friend, Chief Sealth. Maynard, a 42-year-old Democrat, enjoyed his "beverage" and believed vice was essential for economic success. Arthur Denny (below) landed at Alki Point in 1851 at age 23 with his family from Illinois. A year later, they moved to the sheltered side of Elliott Bay and filed land claims. Denny, a conservative Christian and a teetotaler, adjusted Carson Boren's land claim for Maynard. Denny entered into a partnership with Dexter Horton and eventually became one of the wealthiest Seattleites. (MOHAI SHS5595; UWSC Prosch V.1/P2.)

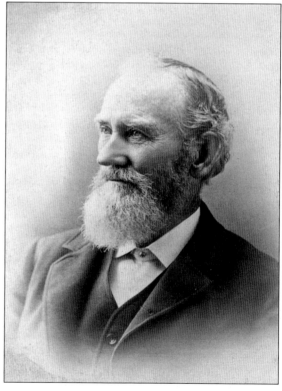

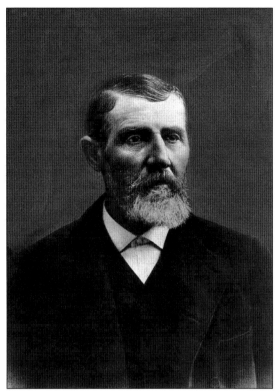

BOREN AND YESLER. Carson Boren (right), Arthur Denny's brother-in-law, built Seattle's first log cabin at the corner of Second Avenue and Cherry Street in 1852. Denny had taken the liberty to adjust Boren's land claim while he was out of town to make room for Maynard. Boren dedicated land at Second Avenue and Columbia Street to Rev. David Blaine for a church and was elected the first King County sheriff. Henry Yesler (below), a 44-year-old teetotaler Whig from Ohio, met Doc Maynard in 1852 while scouting for a location for his steam-powered mill on Puget Sound. Maynard convinced Yesler to build Puget Sound's first steam-powered sawmill at Pioneer Square. Yesler is considered Seattle's economic father and was its first millionaire. (UWSC 223253z; Seattle Municipal Archives 12257.)

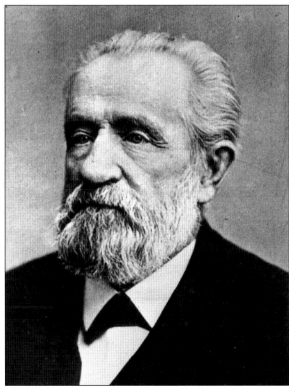

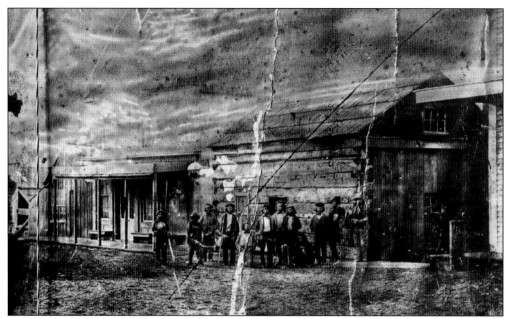

YESLER COOKHOUSE. Built in 1852 of cedar planks, Yesler's Cookhouse was located next to Yesler's Mill at what is today First Avenue South between Yesler Way and Washington Street. In addition to providing meals for mill employees, Yesler's Cookhouse served as the first gathering place for locals and visitors, as well as the first courthouse, church, wedding chapel, and mill office. (UWSC, Prosch, #51.)

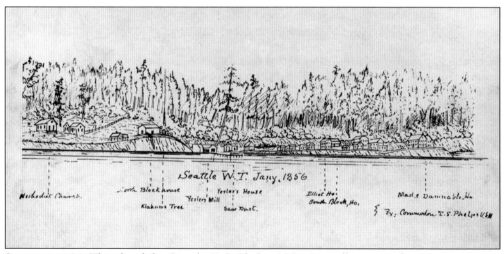

SEATTLE, 1856. This sketch by Comdr. T. S. Phelps, U.S. Navy, illustrates what Pioneer Square looked like in 1856. Old-growth forests were still very close to the original shoreline. The sketch also captures three key themes that would shape Pioneer Square throughout its history: sawdust in the center represents the changing landscapes; the church reflects conservative social issues; and on the right, Madame Damnable's Brothel represents vice. (SPL 13435.)

1856 MAP. This 1856 map illustrates how Pioneer Square was originally located on an island with a strip of land connecting it to the mainland at low tide. The lagoon and tidelands can also be seen, as well as the fact that some of the tidelands had already been filled in with sawdust from Yesler's Mill, just to the right of Yesler's Wharf. (SPL 13434.)

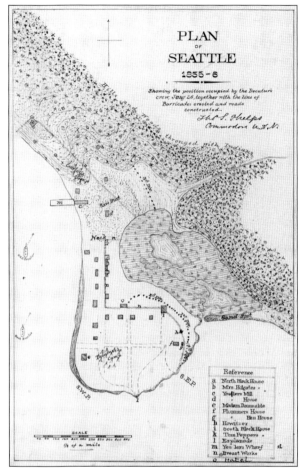

PLAN
OF
SEATTLE
1855-6

Showing the position occupied by the Decatur crew, Jany 26, together with the line of Barricades erected and roads constructed.

Thos S. Phelps
Commodore U.S.N.

Reference
a North Block House
b Mrs Holgates "
c Yeslers Mill
d " House
e Madam Damnable
f Plummers House
g " Ben House
h Howitzer
i South Block House
k Tom Peppers "
l Esplanade
m Yes lers Wharf
n Breast Works
o Hotel

DENNY'S ISLAND. This view of Pioneer Square looking southwest from what are now Fourth Avenue and Cherry Street illustrates the original island. The lagoon can be seen on the right side (east); Elliott Bay is to the west; Alki Point is covered with old-growth forest. Skid Road leads down the hill from the forest to Yesler's Mill and Wharf. (SPL 15067.)

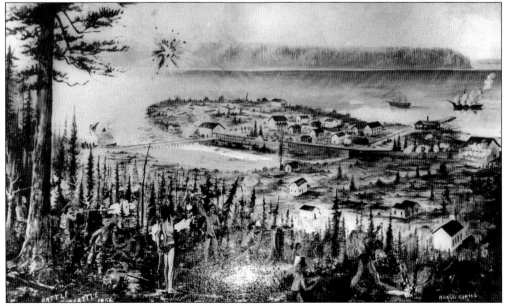

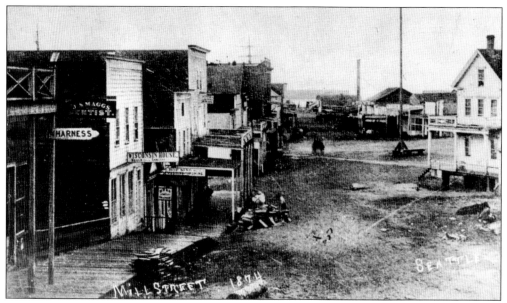

YESLER'S MILL. In the image above, looking west on Skid Road, Yesler's Mill and cookhouse can be seen in the distance. The Occidental Hotel (now Sinking Ship garage) is visible on the right. The tall pole in the wide part of the road is where the pergola is today. Yesler's steam-powered lumber mill started in 1853 and operated seven days a week, 24 hours a day, depending heavily on Native American labor. It can be seen below with smoke coming out of the tall smokestack. By 1865, Pioneer Square's commercial area had developed beyond Yesler's Mill and Cookhouse. The dirt road started as a skid road, where the logs cut from the old-growth forests were greased to skid down the sloping road to Yesler's Mill for processing. Skid Road's name changed over time to Mill Street and eventually to Yesler Way. (SPL 51130; SPL 7314.)

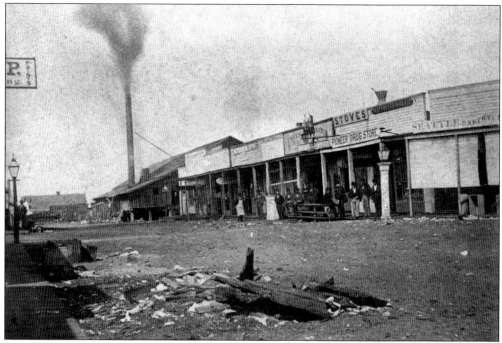

WATER SUPPLY AND HOSPITAL. Basic public health services were provided in Seattle by the mid-1860s. The advertisement for Doc Maynard's Seattle Hospital (right) on Commercial Street between Main and Jackson Streets and Yesler's lumber and flour mill (center) appeared in the *Seattle Gazette* in 1863. Seattle's first water supply, an elevated open flume system on wood poles fed by springs, can be seen below. Henry Yesler's residence at First Avenue and James Street is in the center of the image. Streets were dirt pathways routed around old-growth tree stumps, which were very difficult to remove, requiring dynamite to complete the task. Sarah Yesler, Henry's wife, can be seen on the front porch to the left. The tree line was approximately Fourth Avenue, where the new city hall is located in 2009. (UWSC ADV0146; MOHAI 2002.3.552.)

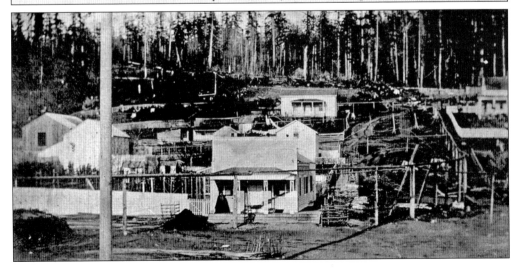

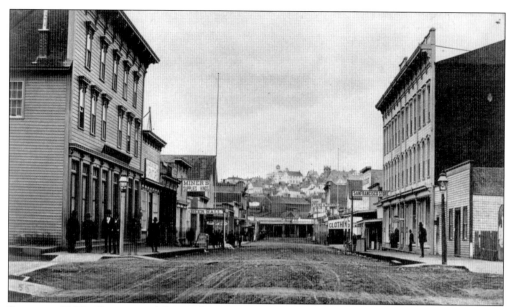

SEATTLE, 1870. Commercial Street (now First Avenue South) above illustrates that, by 1870, Pioneer Square boasted wooden sidewalks and a considerable residential area. (The University of Washington can be seen on the hill in the center). The growing commercial area including Schlweig's Brewery, the Masonic Hall, Pinkham's Variety Store, Levy's Pawn Shop, Eureka Bakery, and Grose's Barber Shop, as well as the Naher, Sullivan, Meydenbauer, and Freeman stores that can be seen below. The Wykoff home (the veranda) is located at Second Avenue and Cherry Street. Dick Atkins's home and J. M. Colman's home can be seen above that. The eastern tree line was at Fifth Avenue. (SPL 150380; SPL 5069.)

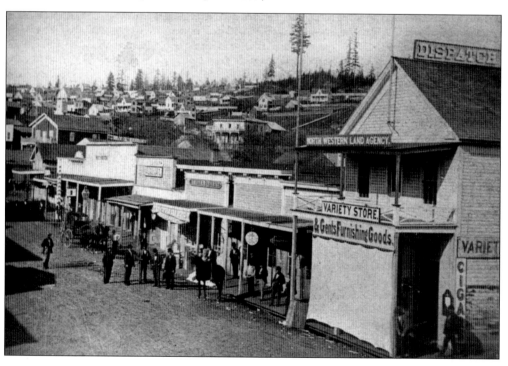

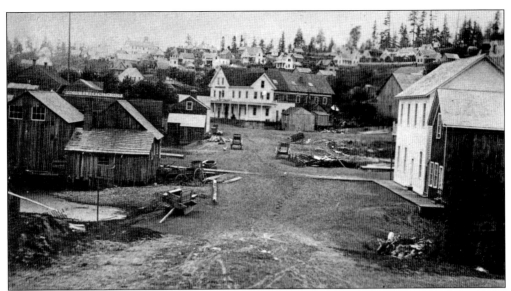

OCCIDENTAL HOTEL. Looking north from Occidental Avenue and Washington Street, the Occidental Hotel is located at the end of the dirt street. Tidal pools can be seen on both the left and right of the dirt road. Tidal influence, combined with rainy weather, plagued Seattle with muddy roads and drainage problems from the onset. The lower image was taken looking northwest on Commercial Street (now First Avenue South) around 1870. Buildings include W. A. Jennings' Store, San Francisco Store, and L. A. Treen Store. People in the image are, from left to right, unidentified, George Reynolds, Perry Parsons, Jesse George, unidentified, ? Melchoir, and two unidentified. Seattle's population had grown from 100 in 1855 to 3,500 in 1878. (UWSC Prosch V2,9; SPL 5105.)

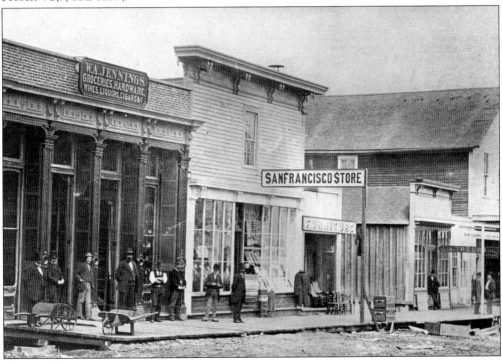

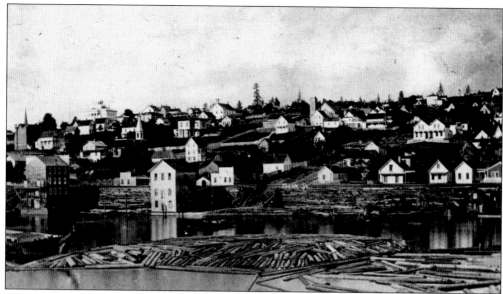

WATERFRONT, 1878. Logs create a seawall along Front Street (now First Avenue) from Madison Street to Columbia Street after a regrade to fill seven ravines between Yesler Way and University Street. Logs waiting to be milled float in Elliott Bay; the bow of the *Winward* is in the left foreground. Buildings include the University of Washington, Brown Church (Second Avenue and Madison Street), First Presbyterian Church (Third Avenue and Madison Street), and Occidental Brotherhood Building (center foreground). The lower image shows Front Street looking south. A. W. Piper holds the hand of his son, Walter Piper, and walks a dog on wooden sidewalks. The white building with the pointed roof on the west is Schlweig's Brewery. The steamer *Zephyr* is behind the brewery. The roof of the Arlington Hotel can be seen in the top center. (SPL 22926; SPL 5129.)

LOOKING SOUTH, 1875. By 1875, Pioneer Square had developed into a peninsula rather than an island. Yesler's Mill and Wharf and the commercial district, along with the regraded Front Street, can be seen in the image above looking south. The lagoon and tide flats are still mostly intact. The image below was taken looking south from Fourth Avenue and Marion Street approximately one block north of the current Columbia Tower. The roads are still dirt with tree stumps dictating travel routes. The shoreline of the tidal lagoon can clearly be seen abutting the old-growth forests approximately where I-5 is today, west of Beacon Hill. On a clear day, majestic Mount Rainer would be seen in the skyline. (SPL 7281; SPL 7320.)

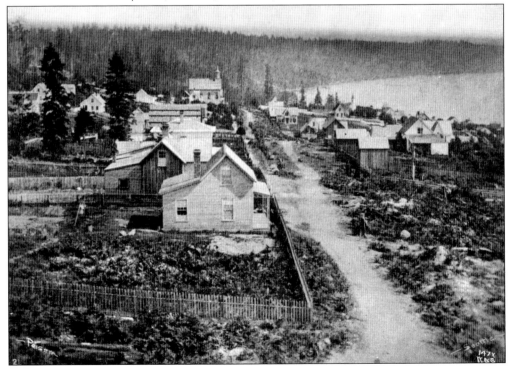

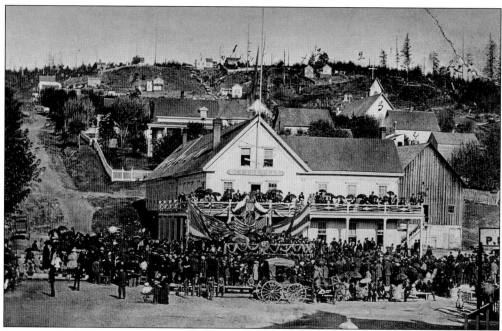

FRONTIER TOWN TO URBAN CITY. A crowd, including newly arrived Reginald Thompson, gathers around the veranda of the Occidental Hotel (above) in 1881 for a memorial service for President Garfield. This hotel, demolished and rebuilt in 1884, is seen on the right below and also on page 31. The elegant Victorian-style Yesler-Leary Building is featured in the center. The first streetcar line in Seattle and the Washington Territory opened in 1884, pulled on tracks by horses. Mayor John Leary and invited guests Sam Crawford, E. B. Downing, and Edward Smart are within the crowd in the new streetcar. By the end of the year, the line had 3 miles of track and four streetcars. The streetcar relied on 20 horses and 10 men to operate it. In the mid-1880s, Seattle's Pioneer Square continued to be the thriving economic, social, and political heart of the city as well as the region. (MOHAI 2002.3.487; MOHAI 2002.3.439.)

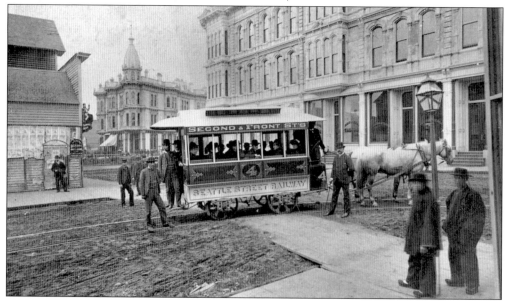

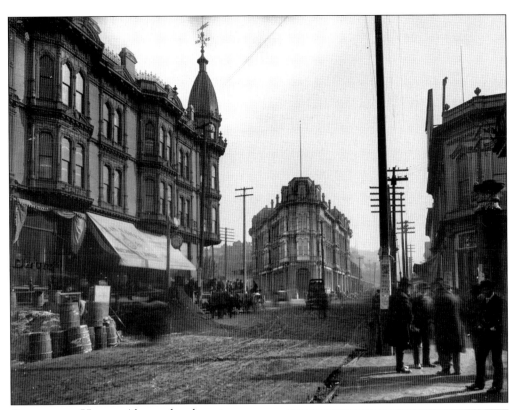

OCCIDENTAL HOTEL. Above, the elegant new Occidental Hotel can be seen looking east from First Street (Front Street/Commercial Street) with Yesler Way (Mill Street/Skid Road) on the right and James Street on the left, meeting at the awkward angles created in the plat dispute between Arthur Denny and Doc Maynard in 1853 that formed Pioneer Place. The opulent Yesler-Leary Building, designed by W. E. Boone (a descendant of Daniel Boone), can be seen on the left. The advertisement at right for the Occidental Hotel appeared in the Polk Directory in 1884; it was touted as the "Largest & Best Appointed Hotel in the Northwest." The sketch is of the triangular Occidental Hotel, designed to fit the awkward lot, viewed from Yesler Way (Skid Road/Mill Street) looking east. (UWSC WAR0188; UWSC ADV0246.)

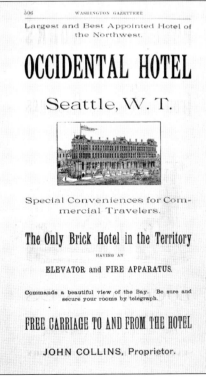

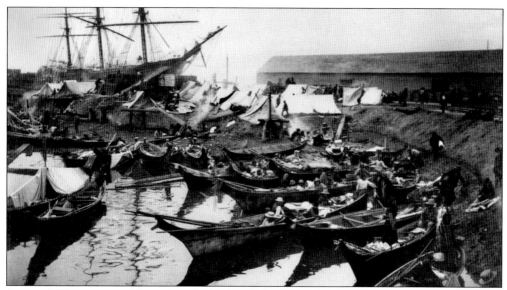

SEATTLE'S WATERFRONT, MID-1880S. In the decade from 1870 to 1880, Native Americans continued to be banned from living in the city (above). Seattle's Pioneer Square and waterfront continued to grow and attract industry, commerce, and population. It was truly the economic heart of the Puget Sound, relying on water-based transportation and shipping. Gone were the old-growth forests on the many hills surrounding Elliott Bay, replaced with homes, businesses, and industry (below). While most of the buildings at the time were frame structures along planked streets, there was also a sense of grandeur in some of the newer construction. The founders' vision was truly taking shape. (SPL 30421; WSHS 1943.42.30420.)

Three

SEATTLE'S
BACHELOR BLUES

As Seattle and the surrounding area's population grew, it became increasingly noticeable that the ratio of men to women was very lopsided. It was said that for every woman there were at least 10 men—and very few of these women were unmarried. Ever innovative, Seattle approached the solution to this delicate dilemma in a variety of creative if not philosophically opposing tactics, resulting in a political and moral debate over whether Seattle should be an "open" or a "closed" city that raged for decades.

Asa Mercer, the newly appointed president of the University of Washington (and also a young bachelor), took a unique approach to Seattle's gender imbalance in 1864. Mercer went to Massachusetts to recruit educated white females of good moral standing to teach Seattle's children and be prospective brides. His first trip resulted in 11 unmarried women making the adventurous trip to Seattle. Mercer's second expedition in 1866 had a goal of 700 maidens but, due to negative publicity, delivered only 34 eligible brides.

The other approach to Seattle's bachelor blues utilized one of the oldest professions, which Seattle officially records as "seamstresses," and reflected a diverse population. Seattle's saloons and houses of ill repute were located south of Skid Road, the muddy road used to skid trees down to Yesler's Mill. This area, originally tide flats, was slowly being filled in with the sawdust from the mill and was also known as "Sawdust Pile," "Lava Beds," "Tenderloin District," and "Skid Row," the latter term coined by historian Murray Morgan. Numerous players in the Pioneer Square area contributed to the leadership of this age-old profession, including John Pinnel's Illahee in the 1860s (and according to author Bill Speidel, the Illahee became the most profitable business in town); Captain Felkner and Madame Damnable's hotel/brothel; Benjamin Sprague's *Gin Palace Polly*; Lou Graham's "first-class madam entertainment business" in the 1880s; and John Considine's People's Theater in the 1890s.

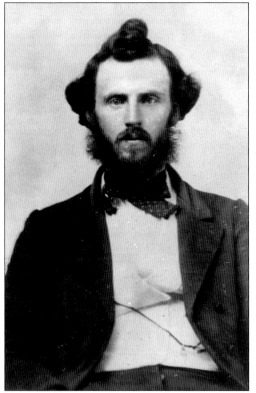

MALES. As the frontier town of Seattle grew, it attracted mariners, loggers, and miners to spend their money on essentials and entertainment. There was, however, a gender problem. Historian Murray Morgan writes, "The bulk of the white population on Puget Sound was young, and unmarried and masculine. Only one adult out of ten was a woman, and rare indeed was the girl over fifteen not spoken for." (MOHAI 2002.3.1496.)

ASA MERCER. Twenty-four years old, single, and newly elected in 1864 as president of the University of Washington Territory, Asa Mercer studied the problem considerably. He was aware that the Civil War resulted in young women outnumbering males on the east coast. Mercer developed a business plan for the transportation of young, moral, educated, unmarried white women to Seattle to educate the city's growing population and hopefully find a husband. (UWSC 2209.)

NEW-YORK TO SEATTLE.

This entitles *Miss Ann S. Conner*

to *one* Passage, in the good Steamship CONTINENTAL,

FROM NEW-YORK TO SEATTLE.

Not valid unless countersigned by A. S. Mercer.

Ticket No. *84*
Berth No. *2. State Room*
A. S. MERCER.

A. S. Mercer

TICKET AND CONTRACT. Ann S. Conner was one of the women that Mercer recruited on his second trip to Massachusetts in 1865 to travel to Seattle. Conner kept a detailed diary and memorabilia of her voyage. It took a lot of courage for a young single woman to leave behind friends, family, and the familiar on a very long trip to the Wild West frontier town of Seattle. The original ticket on the steamship *Continental* from New York to Seattle is above. Right is an excerpt from her written receipt and the contract signed by Mercer and Conner. (Both, UWSC.)

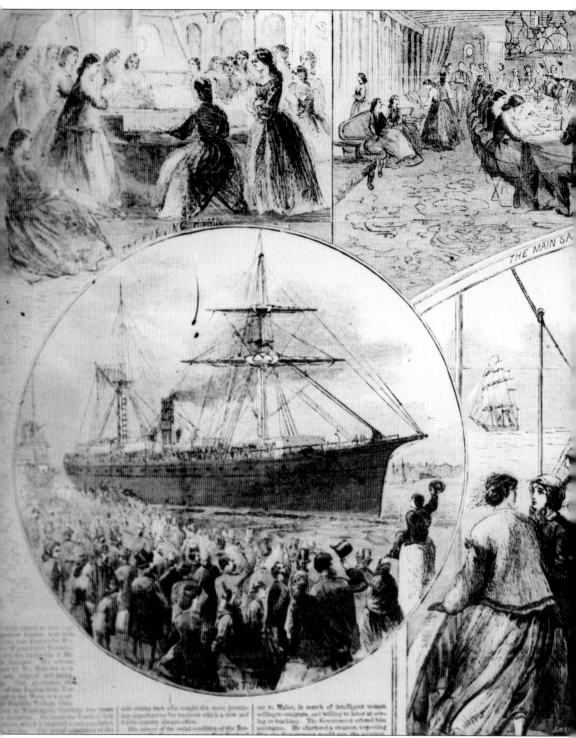

MERCER GIRLS. An 1866 issue of *Harper's Weekly* featured an extensive article on the women, the voyage, and Seattle. Mercer recruited 11 women to Seattle on his first trip to Massachusetts in 1864 and an additional 34 on his second trip in 1866. Mercer's goal for his second recruiting trip was 700

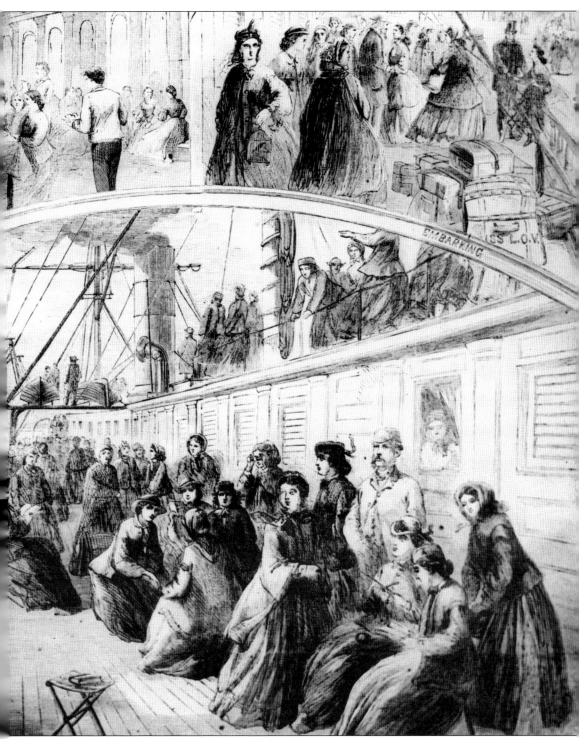

women, but due to poor publicity in the *New York Herald*, many of the women he had recruited withdrew, resulting in disappointing numbers willing to participate. (UWSC WAR0068.)

MADAME DAMNABLE'S. Anne Seagraves writes in *Soiled Doves*: "Mary Ann Boyer, Seattle's 'Madame Damnable,' five feet tall, had a repertoire of profanity that would shock a hardened sinner. . . . Her 'house' overlooked the Sound. . . . At the rear of the house, near the kitchen were several small cubicles, where the 'girls' provided necessary services for the visiting gentlemen." Washington's first territorial legislative session was held at Madame Damnable's, located at the southeast corner of what is now S. Jackson Street and First Avenue South. (SPL 13435.)

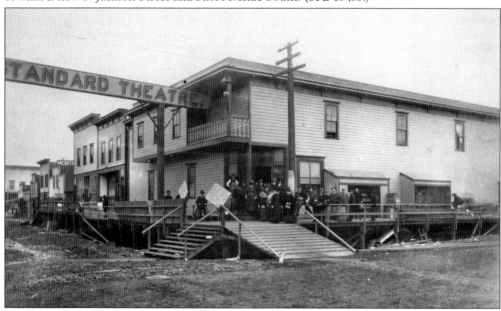

STANDARD THEATER. Box House theaters, located south of Skid Road, developed as an alternative approach to the bachelor problem. Women sang, danced, served beverages, and provided other entertainment in box houses. This entertainment attracted many males willing to spend their money in theaters as well as the commercial establishments in Pioneer Square. Standard Theater was located at the southeast corner of Second Avenue and Washington Street. (UWSC UW14599.)

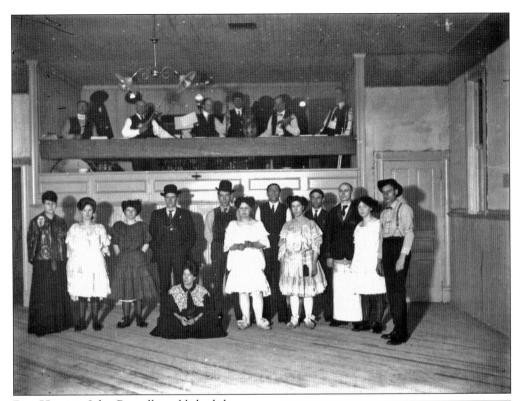

Box Houses. John Pinnell established the Illahee in 1861 and staffed it with Native women from British Columbia, called "sawdust women." Coll Thrush writes in Native Seattle that the Illahee ". . . was one of the largest buildings in Seattle, with a dance floor, a long bar, and a series of private rooms. Described in an 1870 census as a 'hurdy gurdy,'" it was located in the basement at Second Avenue and Washington Street south of Skid Road, similar to the image above. The Illahee soon became the most profitable business in the town. These businesses provided tax dollars that helped the city coffers for projects to improve Seattle's infrastructure. This line of business was not supported by all people in Seattle, and the 1872 *Seattle Post-Intelligencer* article at right summarizes the community outcry—"John Pinnell and his girls must be stopped!" (WSU-MASC PC 18-107; the *Seattle Post-Intelligencer.*)

The City's Mart of Sin Surrounded by Police.

The Inmates of Whitechapel Cut Off From the Rest of the City, and Will Remain in This Predicament Until They Quit Stealing.

Chief Monroe has struck upon a novel plan for preserving order in the notorious Whitechapel district. He has ordered the place quarantined. Such an edict went forth yesterday morning. In accordance with such orders an officer has been placed at each one of the various streets, alleys and byways leading into that district commonly known as Whitechapel, being bounded by Jackson, King, South Third and South Fourth streets.

Just after the great fire the hosts of women who up to that time infested Washington, Main and Jackson streets were driven to the winds. Persistent in their efforts to lead sinful lives the depraved creatures scattered about through the residence portion of the city east of South Fourth street and South of Yesler avenue, at times as far-reaching as South Eighth street.

LOU GRAHAM. Seattle's most famous madam, German-born Dorothea Georgine Emile Ohben (left) used the stage name Lou Graham. She arrived in Seattle in 1888 to become "Queen of the lava beds," specializing in catering to the silk-top-hat-and-frock-coat clientele. Graham established the city's most refined parlor house at the southwest corner of Third Avenue and Washington Street. The bordello burned in 1889 after only 18 months of business; however, Graham had accumulated enough wealth to be the first property owner to rebuild and expand. In *Sons of Profits*, author Bill Speidel writes, "More city business was transacted at Lou's than at City Hall." The building (below) still exists, now called the Washington Court Building, and houses the Union Gospel Mission Office. Graham, 44, passed away in 1903, reportedly from an occupational health hazard. (Merchant Café; J. Keniston-Longrie.)

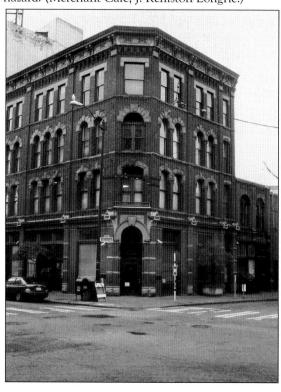

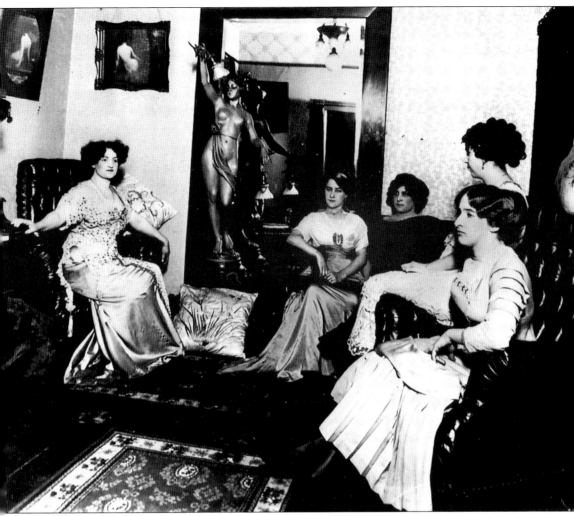

LOU'S SEWING CIRCLE. Underground Tour founder and author Bill Speidel writes, " Lou Graham would provide a collection of the most gorgeous, the most talented, the most understanding hostesses from every corner of the globe . . . women who could discuss the opera, or politics, or economics, or world conditions on an intelligent level with the leaders of America. . . . A fine parlor would be located on the first floor for those who sought no more than a quiet drink and pleasant companionship against a background of fine music. For those who felt the need of deeper therapy, commodious quarter would be provided in the upper floors . . . Lou's principal method of advertising took the form of carriage rides up and down main streets on Sunday afternoon. Dressed in their best finery, the young ladies of her establishment were regularly put on display. Lou accompanied the girls on these trips, waving grandly here and there to the leading citizens who were her personal friends. In Lou's days, when prostitutes were booked in city jail, they listed their occupation as 'seamstresses'." (Bill Spiedel's Underground Tour.)

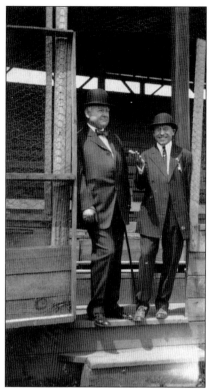

JOHN CONSIDINE. Born in Chicago, John Considine (left) landed in Seattle in 1889. By 1891, he was manager of the People's Theater, a box house in Pioneer Square. Considine did not drink or gamble and was a faithful family man. He managed a business whose profits depended on female performers hustling drinks, and according to historian Murray Morgan, "If the girls wished to peddle more personal wares, management did not object." An innovative businessman, Considine created specialized roles for his girls, hiring professional actresses for the stage and others to serve drinks in the dark booths. He prospered greatly until the Panic of 1893 and the following economic depression. He returned with gusto during the Klondike gold rush and mined the miners from the People's Theater basement at 172 S. Washington Street. (UWSC SAY05361; MOHAI 1983.10.7546.)

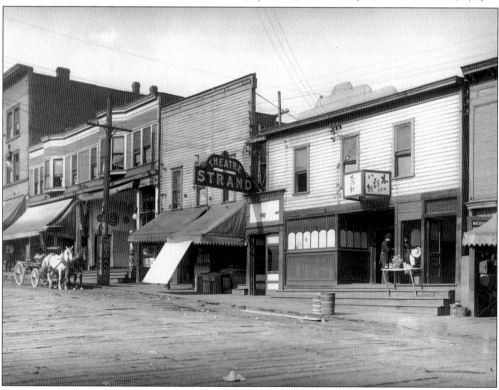

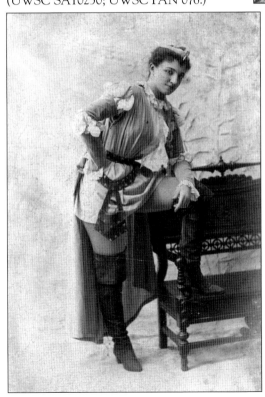

BURLESQUE AND VAUDEVILLE. Considine brought entertainment to a new level in Seattle, including "Little Egypt" from the Chicago World's Fair (right) and Adele Farrington (below) in costume, examples of the entertainment during a time when it was inappropriate for a woman's ankle to show. People's Theater posted bands outdoors to attract customers, competing with other venues and at times against the Salvation Army's band for music and souls. (UWSC SAY0250; UWSC PAN 076.)

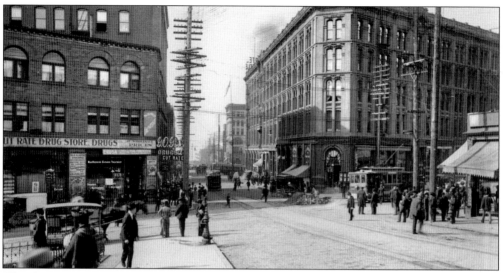

WHO SHOT THE SHERIFF? Police Chief William Meredith began an anti-vice campaign, enforcing laws against Considine but not against his rivals. The issue escalated, and Meredith resigned, armed himself, and went after Considine. The dispute ended at G. O. Guy's drugstore (upper left) at Second Avenue and Yesler Way, kitty-corner from today's Smith Tower, when Meredith shot Considine point-blank. Considine managed to pull his gun and kill Meredith. After this event, Considine reinvented himself, changed clientele, established well-appointed dry establishments with movies, and developed the first vaudeville circuits in the west. (UWSC CUR 280.)

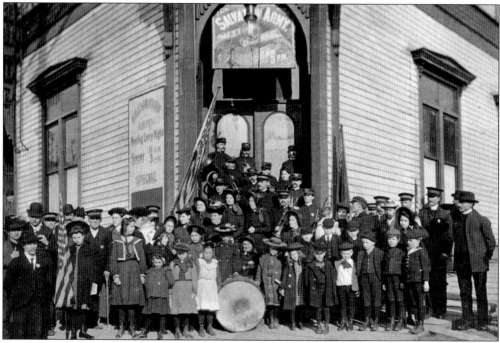

SALVATION. The oldest profession in the world, which flourished on the south side of Skid Road, is said to have created a human trafficking market, taking advantage of women and minorities. The Salvation Army was an early intervener and continues to help the homeless, unwanted, and disenfranchised today. (MOHAI 17998.)

Four

THE GREAT FIRE OF 1889

Seattle grew significantly over the years, and by June 1889, its population was estimated at 31,000 people. Pioneer Square was no longer a frontier town; it was a city. It had several elegant hotels, including the opulent Occidental Hotel at Second Avenue and Yesler Way. The Frye Opera House dominated the skyline, and wharves along the waterfront, known as Front Street (First Avenue), were bustling with people, ships, and cargo.

Thursday, June 6, 1889, started out as an exceptionally lovely day in Seattle. The weather had been unseasonably warm and sunny. The sky was blue, the mountains clear, and Elliott Bay sparkled like diamonds in the sunlight. People were bustling through their everyday business with a special happiness that Seattle people get when the gray clouds and rain go away and the sun comes out. About 2:40 in the afternoon, a small pot of glue accidentally boiled over onto the basement floor of the Pontius Building at Front Street (First Avenue) and Marion Street, which ignited turpentine-soaked wood shavings covering the floor.

A lack of water pressure combined with low tide, short fire hoses, wooden structures, and a strong wind created the worst set of circumstances imaginable for Pioneer Square. Seattle's Great Fire of 1889 burned to the ground over 125 acres, 30 city blocks, and the heart of the town, including every wharf and mill from Union Street to Jackson Street, in a little under 12 hours. Miraculously, no lives were lost.

As devastating as the Great Fire of 1889 was, Seattle did not lose its spirit. In fact, the citizens quickly realized this was an opportunity to fix some of the things the city had not gotten quite right the first time. The community quickly got together and made major decisions on how they wanted their future community to look and function. They replatted the street grid; outlawed wooden buildings; established a fire department; voted in a public water supply system; and decided to elevate their city from 10 to 40 feet to ensure that they could flush their toilets without having to gauge the tide.

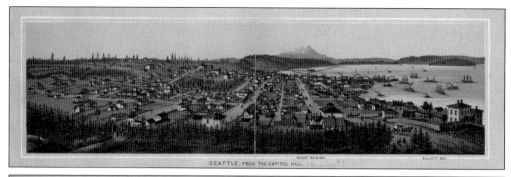

SEATTLE, FROM THE CAPITOL HILL.

OLYMPIC RANGE, FROM SEATTLE HARBOR.

CLEAR SKIES AND MOUNTAIN VIEWS. On June 6, 1889, there were no clouds in the sky. The Olympic Mountains could be seen to the west over Elliott Bay, and Mount Rainier could be seen to the south over the tidal lagoon from Pioneer Square. The waterfront was bustling with commerce, industry, residents, and travelers. Seattle's Pioneer Square waterfront had grown to be the most significant port in Puget Sound. The weather had been sunny for days and was forecast to stay that way. A breeze was blowing from the north-northeast. Below, the elegant Yesler-Leary Building shimmered in the sunshine. (UWSC Prosch 66; UWSC Prosch 5282.)

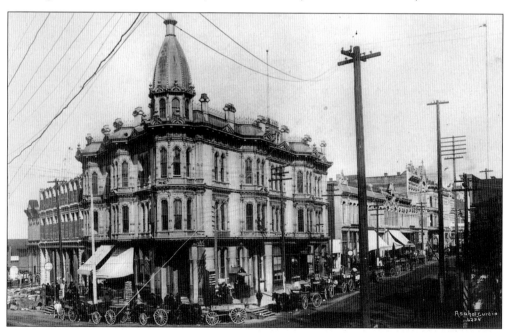

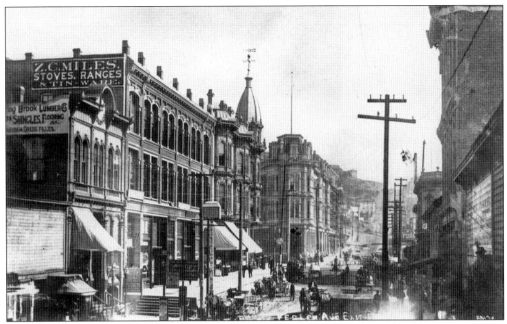

BUSTLING COMMERCIAL CENTER. Looking east on Yesler Way (Skid Road/Mill Street), Pioneer Square's commercial center can be seen above in this image taken on June 5, 1889. The Occidental Hotel is the triangular building on the far left, next to the newly built Yesler-Leary Victorian-style business offices. Other buildings in the image include the Post Building (housing the *Seattle Post-Intelligencer* and the post office), Schwabacher Brothers and Company, and the Colman Building. Below, on the same day, these buildings are seen looking west on Yesler Way (Skid Road/Mill Street). Business was brisk, and Seattleites went about their daily tasks with a lightheartedness that was a frequent occurrence when the sun appeared in the often cloudy, drizzly city. (UWSC CUR975; UWSC CUR969.)

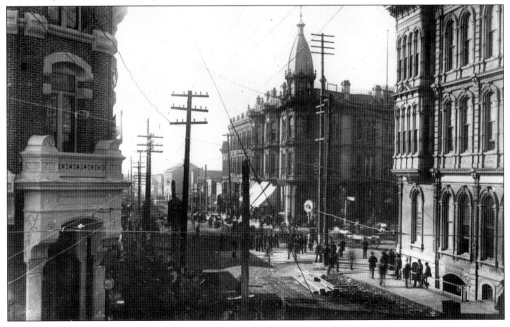

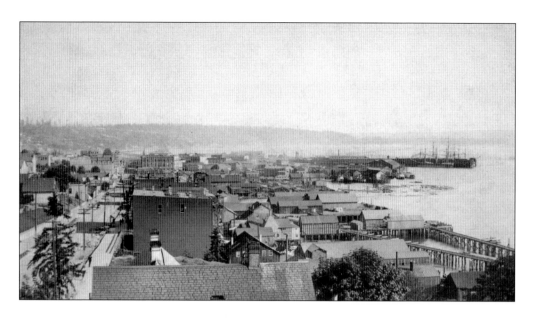

FRONT STREET. Looking south (above) and north (below) from Madison Street on Front Street, wooden sidewalks flank wooden streets and buildings, including the Kenyon Block. *Skid Road* author Murray Morgan characterized this typical afternoon at 2:30: "F.M. Gordon, newly arrived from Maine, having made up his mind that Seattle was a place with a predictable future . . . paid twenty-five hundred dollars—his entire capital—for a fourth interest in a tailor shop on Front Street. At about the same time that Gordon received his receipt, Madame Feitsworth-Ewens, who specialized in reading the future was giving a customer some advice in the nearby Pontius Building; Dr. Sturgens, a dentist . . . was peering into the mouth of a logger. On the ground floor, J.P. Madigan was showing some boots to a housewife." (MOHAI SHS1376; UWSC CUR1020.)

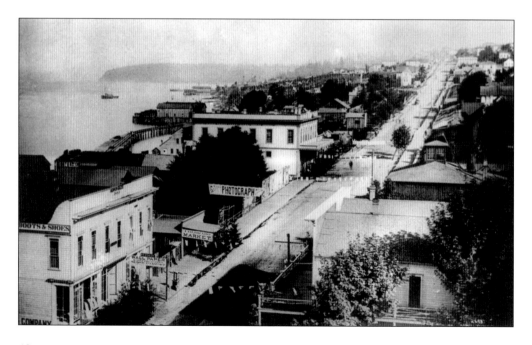

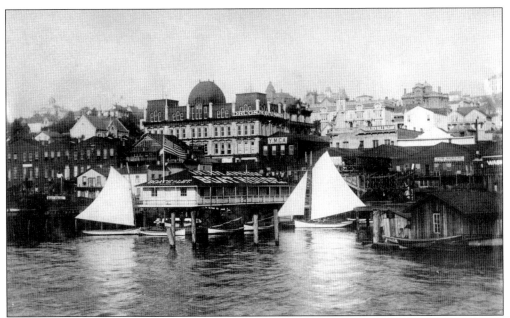

FLAMING GLUE. The large domed building above is the Frye Opera House, and across the street on the water side, far left, is the Pontius Building. In the basement of the Pontius Building, James McGough, who ran a paint store and woodwork shop, was finishing a cabinet. His assistant, John Back, was heating glue over a gasoline stove. Around 2:40 p.m., the glue pot boiled over and caught fire. Flaming gobs of glue splashed on the floor, which was littered with wood shavings and soaked with turpentine. McGough tried to douse them with water from the fire bucket; the water mixed with the turpentine and burst into flame. Even before the cabinetmaker rushed from the building, someone on the street saw the smoke (below) and called the fire department. (UWSC Prosch V2,36; MOHAI 2002.3.405.)

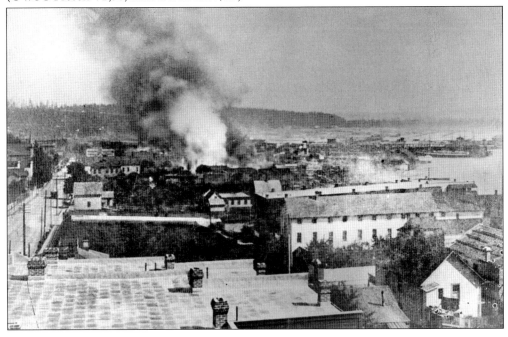

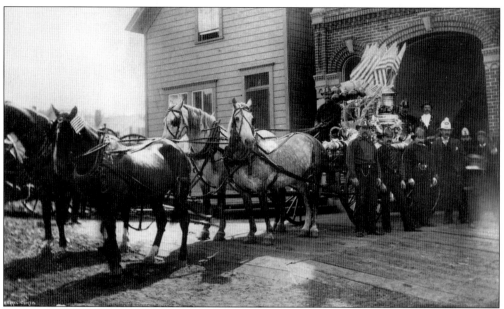

FIRE DEPARTMENT RESPONDS. The Engine House and Fire Company, located on Columbia Street between First and Second Avenues, responded with a hose cart pulled by horses, men, and boys (above). Close behind the cart came the town's first steam fire engine, staffed with volunteer firefighters. The hose company tied up to the hydrant at Madison Street; the steam engine took the next hydrant, two blocks away (below). Flames burst through the wooden ceiling of the Pontius Building. The burning glue and leather threw off so much smoke that the firemen had trouble finding the heart of the flame. Firemen sprayed water onto the walls and roof of the two-story wooden building. Someone pried off the clapboards at street level only to discover the basement was engulfed in flames. (UWSC PSE127; SPL 22900.)

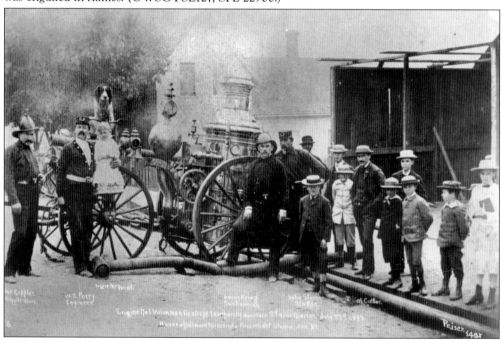

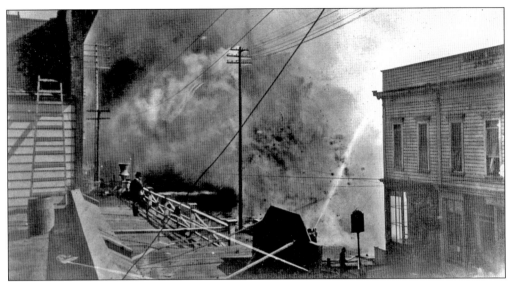

FLAMES SPREAD. The firemen poured water into the basement, but it was too late; the fire was out of control (above). Flames burned through walls into the Denny Block, a two-story wooden building on the west side of Front and Marion Streets. Several times windowsills on the Opera House caught on fire, but each time the firemen were able to smother the flames with a stream of water. Shortly after 3:00, a fireball carried high by an updraft of hot air from the Denny Block fell on the Opera House roof (below). Low water pressure resulted in water being unable to reach the roof, and it caught on fire. Morgan writes, "Inside the building stagehands worked desperately to haul scenery to safety, but the magnificent Frye Opera House was lost." (SPL 5220; UWSC Hamilton V.5, 9007.)

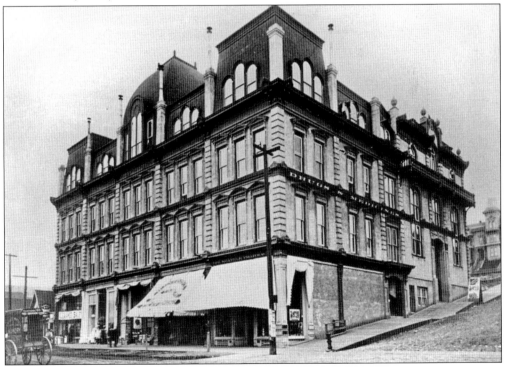

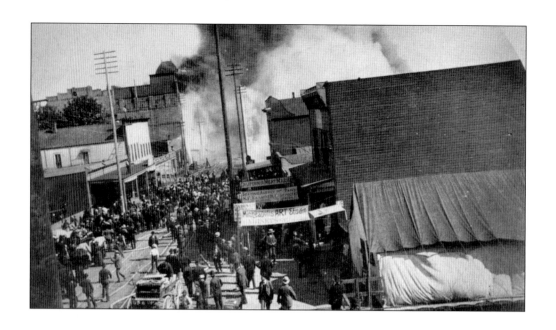

FRONT STREET LOOKING SOUTH. A mere half hour after the glue boiled over in the Pontius Building basement, this was the scene looking south on Front Street from Spring Avenue. Crowds gathered to watch. The dome of the 1,300-seat Frye Opera House was ablaze, and billowing smoke can be seen to the left above. By 4:00 p.m., it was apparent that the business district was doomed. The roar of the fire and whistles from mills and ships could be heard for miles. Church bells tolled frantically, signaling the need for help. The cloudless day allowed Seattle's smoke to be seen from Tacoma, 30 miles to the south (below). Telegraph messages for more equipment went out to cities including Tacoma, Portland, and Victoria, Canada. (SPL 23111; *Harpers Weekly*.)

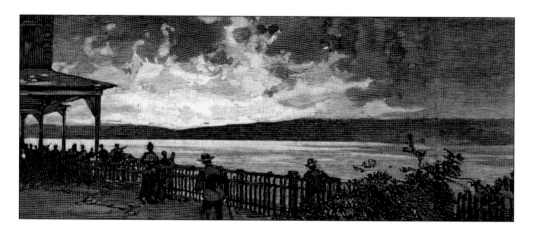

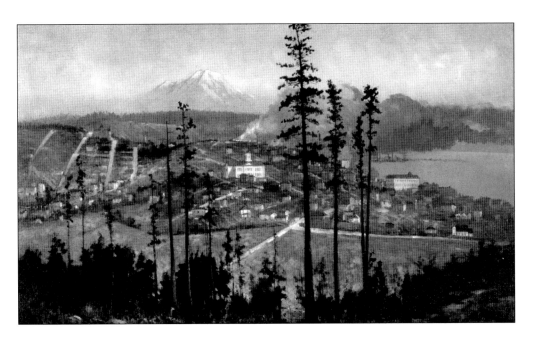

SMOKE. Billowing black, gray, and purplish smoke could be seen for miles. This painting from Queen Anne Hill shows the smoke early in the blaze; majestic Mount Rainer could be seen hovering on the horizon. Denny Hill (prior to regrading) blocks the view of Pioneer Square. The wharves appear to still be intact at the snapshot in time above. Historian Murray Morgan writes, "The first shop the fire reached in the Denny Block was the Dietz and Mayer Liquor Store. Whisky barrels in the basement exploded and showered the walls with flaming alcohol. When the Crystal Palace Saloon and Opera House Saloon caught fire a moment later more high-proof fuel was added to the flames. . . . Young Mr. Gordon had only the receipt to show for the money he had invested." (MOHAI MP1721; UWSC Prosch 23.)

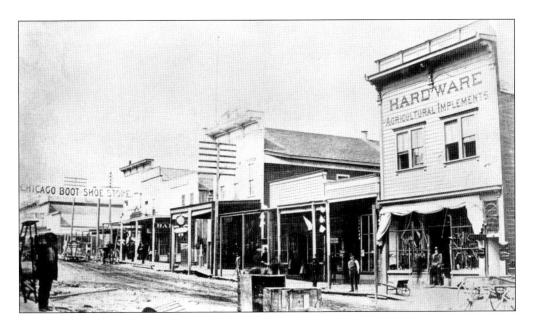

FIRE JUMPS COLUMBIA STREET. The fire roared on. It jumped Columbia Street (above) and swept south, near where the Metropolitan Grill is today. It crossed Second Street and closed in on Trinity Church on Third Avenue. The courthouse was located across the street from Trinity Church (below). A murder trial was in progress in Judge C. H. Hanford's court. He kept the court in session while fire bells clanged in the streets below and smoke poured in the windows. Finally, when the Trinity Church bell tower across the street was aflame, Judge Hanford adjourned the court. Hanford, along with the help of Lawrence Booth, saved the courthouse by climbing onto the roof and using the halyards on the flagstaff to haul buckets of water to douse the flames. (SPL 15278; UWSC Prosch 28.)

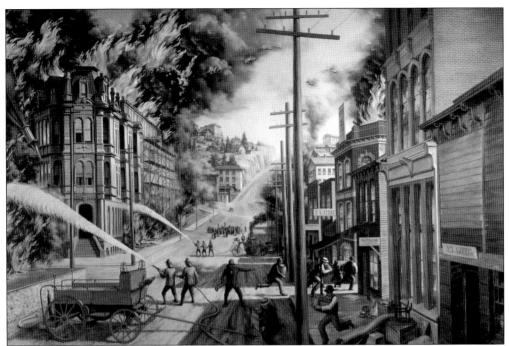

LOW TIDE AND FUEL. The Colman Building, the Occidental Hotel, the Yesler-Leary Building, the Post Building, and the Commercial Mill soon caught fire (above). Steam Engine No. 2 was on a wharf behind the Colman Building, but the tide was out, and the hoses would stretch only to the side of the building away from the fire. As more and more hoses came on line, pressure fell. The wooden water mains were too small. The streams dwindled until little more than a trickle came from the brass nozzles. When the fire reached the Gordon Hardware Company (below), 30 tons of cartridges began to explode; the fusillade lasted half an hour. A few minutes later, the flames swept into the Seattle Hardware Store, and another 20 tons of ammunition went off. (SPL 5066; MOHAI MP1953.545.1.)

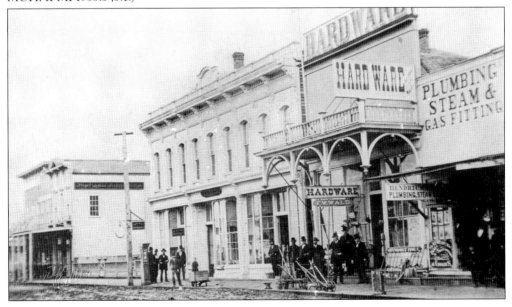

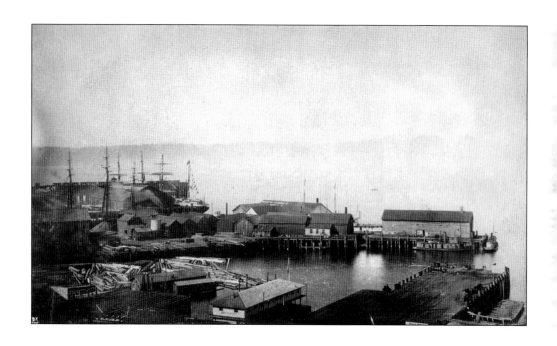

MAYOR ORDERS DOCK BLOWN UP. All maritime vessels loaded what they could save from wharves and cast off. Mayor Robert Moran, who took over for the acting fire chief, ordered Colman Dock blown up to form a fire gap. The June 7, 1889, *Seattle Post-Intelligencer* reports, "An effort was made at 4 o'clock to blow up the Colman dock by placing large charges of dynamite and other explosives under its center, but it proved abortive, and the building burned from one end to the other." (UWSC Prosch; UWSC SEA1883.)

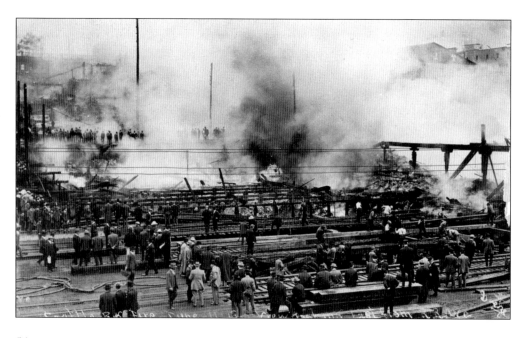

POST-INTELLIGENCER.

VOL. XVI. SEATTLE, WASHINGTON, FRIDAY, JUNE 7, 1889. NO. 27.

POST-INTELLIGENCER.
…RARY HEADQUARTERS—Cor. Fourth
Columbia streets.

BY MAIL:
1 year, in advance.................$10 00
1 month, in advance.................. 1 00
…ly, 1 year, in advance............... 2 00
…ly, 6 months, in advance............ 1 25
…ay, 1 year, in advance.............. 2 00
…ly and Sunday, 1 year, in adv'ce 3 50
BY CARRIER (in the city.)
, per week...................25 cents

SEATTLE, FRIDAY, JUNE 7, 1889.

THE FIRE.

…e story which is told this morn—
…eeds no elaboration. Our whole
…ness and commercial district, the
heart and center of the city, up—
…s of fifty blocks of business build—
…s this morning a glowing heap
…nes. But a single important busi—
…building, the Boston block, is left
…ning. Every bank, every whole—
house, every hotel, every news—
…r office and nearly every store has
…swept out of existence. Property
…h yesterday morning represented
…rds of ten millions of dollars has
…utterly destroyed. The facts
…k for themselves. In the presence
…h a calamity it would be useless
…ultiply phrases. No other Amer—
…city ever suffered a loss propor—
…tely great.

…great as is this calamity there
…d fortune in the fact that it is at—
…d with comparatively little per—
distress. The residence districts
…n practically untouched, and
…those whose money losses are
…le are comfortably housed in
accustomed homes. It is an—
fortunate fact that the heaviest
…will fall upon those best able
…pport them and to replace the
…rty which has been destroyed.
…he part of those who might be
… poor there is scarcely any di—
…ioss, and the indirect losses will
seriously affect them.
…ile Seattle has received a terrible
… there is not the slightest danger

A SEA OF FIRE

The Business Part of Seattle in Ruins.

Sixty-Four Acres of Ground Swept.

Thirty-Two Blocks of Smoking Debris.

The Loss Will Exceed Ten Millions.

A Little Blaze at Madison Street
Becomes a Giant of Destruction
Ravaging All the Lowlands to
the South—Fire-Proof Brick and
Frail Wood Alike Food for the
Forked Tongues---The Phœnix.

The business portion of Seattle is in
ruins. Between the hours of 2 and 3 o'clock
yesterday a wall of fire sprung up at Mad—
ison and Front streets, and traveled south—

men to stand in front of the wall of fire to
work on the opera house. The whole
block of wooden buildings north of the
opera house, had by this time shared the
general fate and were fast disappearing in
fire and smoke. Virtually nothing could
be done toward saving the opera house.
Men tried to brave the intense heat from
the burning row across the street, but were
driven back with scorched faces and
burning garments. The very hose melted
and the firemen were forced to drag it
back and reach the fire from Second street.

CONTROLLING THE MOB.

Up to this time Marshal Murphy had
been the only head of the fire department;
but Mayor Moran and Councilman Durie
now appeared on the scene and attempted
to bring order out of confusion. Parties
were organized to carry goods out of the
buildings in the path of the flames and the
side streets in a few minutes were blocked
with merchandise. Chief Butterfield
swore in over 100 deputies and instructed
them to arrest every man found steal—
ing, and in a few minutes the
rabble had become a working crowd, led
by intelligent men.

The flames hung onto the Denny block
and the firemen who covered the north
end of the Colman block, next to it on the
south, could have checked them there had
it not been for the lack of water. At 3:30
the big Preston book and ladder truck
came tearing up Front street and turned
up Columbia to go around to the rear end
of the Opera House block; but before it
had reached there the big building was a
skeleton, with a window showing
flame and smoke.

SPREAD OF THE FLAMES.

At 4 o'clock the flames leaped across
Marion street and the Colman block on
the west and the Renig block on the east
side of Front were soon in the center of the
fiery sea.

An effort was made at 4 o'clock to blow
up the Colman block by placing large
charges of dynamite and other explosi—es
under its center, but it proved abortive,
and the building burned from one
end to the other. The explosions
shattered the windows in the big brick
blocks south of Columbia, and several per—
sons were badly cut by the falling glass.
At five minutes past 4 o'clock the Kenney
brick block on the corner of Front and Col—
umbia caught fire at the top. Engine No.
1 was then forced to pull up and
attach at the corner of Cherry street. Be—
fore a stream could be started again every
building north of Columbia street was on
fire.

AT THE SAN FRANCISCO BLOCK.

The San Francisco building was the next
apparent barrier to the progress of the
flames. Every window of the building
was curtained with heavy wet blankets.
A charge of powder was placed under the
white block across the street, but it did not
move the building. In a few m nutes
…caught on fire, from the Kenney block,

which could be removed before the flames
reached. Boyd's photograph gallery, on
the opposite corner, was next enveloped.
The buildings in this block—the Northern
Pacific Land Company's office, St. Charles
hotel and the building occupied by the
Congress saloon, were swept away.

SAVING THE BOSTON BLOCK.

The Boston block, opposite Boyd's gal—
lery, one of the finest structures in the city,
was in imminent danger for some time,
the window frames being ignited, but the
timely assistance of a number of spec—
tators prevented destruction. Two bucket
brigades were formed—one extending up
the front stairs to the fourth story, and the
other reaching across Columbia street, up
the side entrance to the second flat. The
building caught from the adjoining
wooden structure occupied by J. S. Ed—
wards, which was destroyed. The win—
dows in the front were all smashed, and
the plastering somewhat injured by water.
The structure would undoubtedly have …
consumed if the bucket brigades had not
been organized, as the efforts of the fire de—
partment were now directed altogether to
saving the Front street bricks.

The Colonial block, northeast corner of
Second and Columbia streets, was ablaze
several times, but the efficient service of
the brigade was again called into action,
and the building was saved. No damage
save the flooding of the building and
broken glass resulted.

The buildings on Second, between James
and Cherry, caught at 5 p. m. and were
destroyed in about half an hour. This left
the way clear for the Occidental, which
the flames reached at about 5:45.

THE FIRE TRAVELS NORTH.

The flames had swept down Front street
nearly to Marion before they crossed to the
north side of Madison. The commercial
mills were in a mass of flames at 3 o'clock
and the fiery flood swept up under the
wharfing, first attacking the blacksmith
shop. One stream of water was being
played upon the "Times" building, but it
was futile, as the fire soon broke out in
every part of the block. Meanwhile the
warehouses and whole wharving on the
northern side of Madison were igniting.
From this point up Front and back to the
water edge the flames surged in living
waves without any attempt being
made to check them other than
futile efforts with buckets and
garden hose. Warehouse after ware—
house fell in with a crash and the wooden
business blocks on both sides of the street
rapidly going down before the fiery tem—
pest. The excavation for the Holyoke
block, Front and Spring streets, checked
the progress on the east side of the street,
and undoubtedly saved the next block and
the residence portion of Second and Third
streets, b yond Spring street. On the west
side to the water's edge was one great fiery
cauldron.

Starr brick block was in flames at 5:30
and all south of it destroyed. The fire
was stopped by this building for a time,

most capacity it steamed out into the ha—
bor.

In the meantime the steamer Mexico,
which was lying at the city dock was load—
ing with merchandise brought from the
stores by the drays, and after taking all the
vessel would hold from the wharf,
steamed into the harbor.

The entire shipping in the
harbor, having plenty of time to do so,
pulled out into the stream, and it is well
it did so, for every wharf from the foot of
Union street to Jackson was consumed.

Among the ships in port were the steam
ship Ancon, Captain Wallace; steamship
Spartan, Captain Palito; and the Palmyr—
ico, Captain Huntington; the Palmyr—
and many other ships and smaller vessels
the names of which it was impossible to
learn.

The craft in the harbor did much good
work and by their timely assistance saved
a great deal of property. Amongst these
were the steamer Goliah, Blakely; Mastick,
Henry Bailey, Washington, and the
schooner Teaser.

BARRIERS SWEPT AWAY.

Meanwhile the tempest of flame was
steadily sweeping down Front street.
The Yesler-Leary building resisted the
flames for a long time, but the insidious
enemy finally entered from the rear, and
having once gained an entrance spread
through the entire building like a flash.
The walls of the San Francisco, Poncin
Union and Merchants' bank blocks had
barely fallen in when the topmost pinna—
cle of the big Yesler-Leary building be—
came the fiery center of the column of
destruction.

The POST-INTELLIGENCER building on
Yesler avenue to the west of the Yesler
Leary building was licked up in a trice by
the flames, which then walked with steady
march along the wooden row toward Yes—
ler dock.

On James and Second Streets the fire be—
destroyed every building up to the Butler
block by twenty minutes past 6 o'clock.

BURNING OF THE OCCIDENTAL.

The Occidental hotel then stood as the
only barrier between the flames and the
sawdust flats, the most populous portion of
the city. For a time it appeared as if the
huge triangle of brick and stone would
stand the storm and aid in conquering the
fire. A line of hose was passed to the roof
but again the water supply failed and the
firemen stood holding the impotent hose
while the flames jumped across the nar—
row street and touched cornice and win—
dow sill. Within ten minutes the entire
north side of the big hotel was a sheet of
fire.

HELP FROM TACOMA.

A yell and cheer at this juncture an—
nounced the arrival of a hose team from
Tacoma. Dispatches had been sent at 3
o'clock to Tacoma, Port Townsend and
Portland for assistance. The Tacomans had
answered promptly … the … cal
and about forty men with a hose team and

A SEA OF FIRE! The *Seattle Post-Intelligencer* headline of June 7, 1889, says it all. Detailed hour-by-hour accounts of the fire in the multipage spread is a truly amazing show of dedicated journalism, as the paper's headquarters in the Post Building was lost. The paper records, "The Post-Intelligencer Building on Yesler Avenue to the west of Yesler-Leary Building was licked up in a trice by the flames, which then walked with steady mark along the wooden row toward Yesler dock." See page 61 for before and after images of the Post Building. Sadly, after over 145 years of printing news, the *Seattle Post-Intelligencer*'s presses fell silent on March 17, 2009. (SPL.)

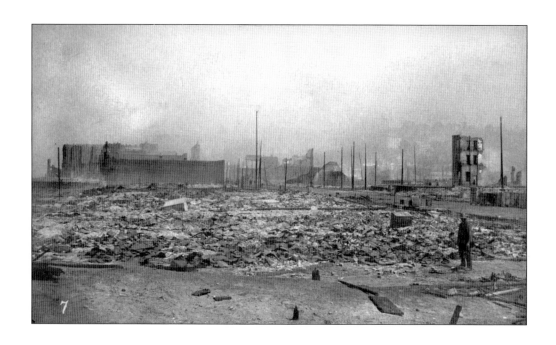

UP IN ASHES. Within 12 short hours, ashes had been made of nearly four decades of progress in Pioneer Square. Over 125 acres and 30 city blocks were gone. The entire heart of the town and its business district had gone up in ashes. Every wharf and every mill as far north as Union Street and as far south as Jackson Street was gone. Above, a man stands in the ruins on Commercial Street (First Avenue South) looking northeast from Jackson Street. The Dextor Horton Block ruins are in the center foreground. Below is a view looking south from Second Avenue and Marion Street, near where the fire started, the morning after the fire. (SPL 5217; WSHS 592.27.115.)

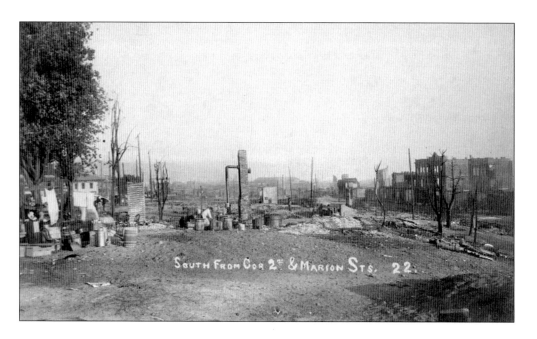

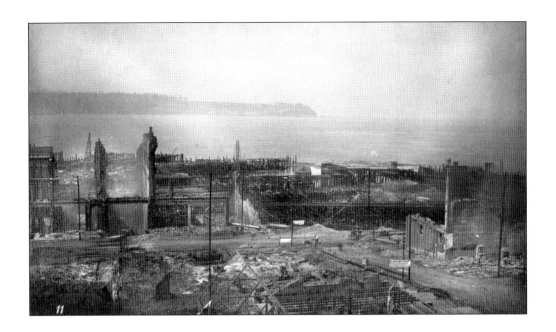

CITY IN RUINS. The wharfs, which had been bustling with business just the day before, were in charred ruins. The image above was taken looking west over Elliott Bay from the Boston Block at Second Avenue and Columbia Street. Below are the stark ruins of the city as seen looking south on Commercial Street (First Avenue) from Washington Street. Note the streetcar tracks, which have warped due to the heat of the fire. The men in the image are most likely surveying the damage, dressed in their top hats and suits. The heavy scent of smoke filled the air. (SPL 14592; SPL 5145.)

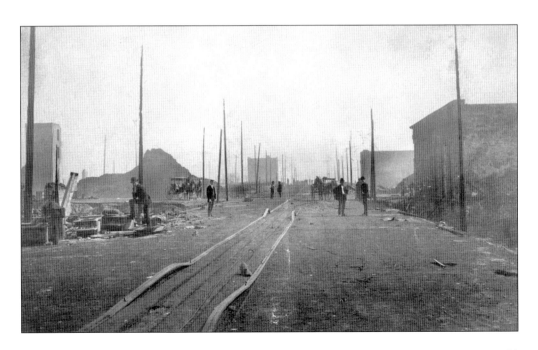

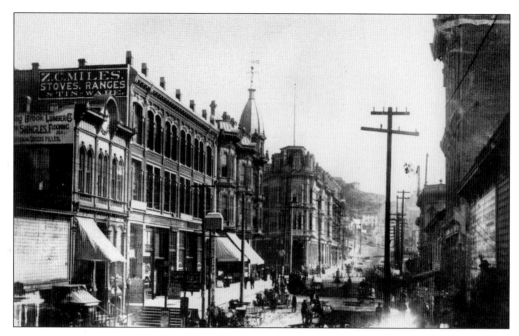

OCCIDENTAL HOTEL. The *Seattle Post-Intelligencer* reports, "The Occidental Hotel then stood as the only barrier between the flames and the sawdust flats, the most populous portion of the city. For a time it appeared as if the huge triangle of brick and stone would stand the storm and aid in conquering the fire. A line of hose was passed to the roof; but again the water supply failed and the firemen stood holding the impotent hose, while flames jumped across the narrow street and touched cornice and window sill. Within ten minutes, the entire north side of the big building was a sheet of fire." These before (above) and after pictures (below) of the Occidental Hotel looking east on Yesler Way tell the striking story of the fury of this mighty fire. (MOHAI 5195; SPL 14596.)

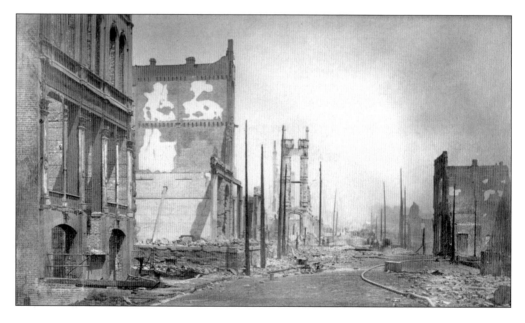

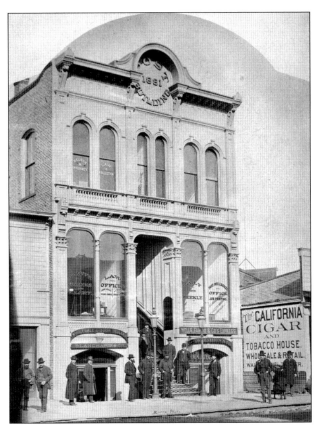

POST BUILDING. The Post Building was built in 1881 and was at a key location in Pioneer Square next to the Yesler-Leary Building, just down Yesler Way from the Occidental Hotel. It housed the U.S. Post Office, the *Seattle Post-Intelligencer*, and a bank and brokerage firm (right). The ruins (below) stand in stark contrast to the vibrant business it had been just the day before. Men dressed in coats and top hats, the style of the day, milled around the ruins, awed by the magnitude of the damage. (SPL 15044; UWSC SEA1247.)

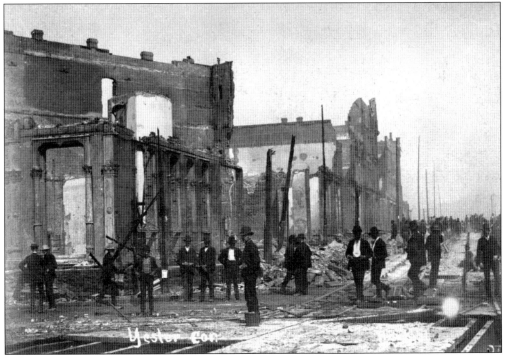

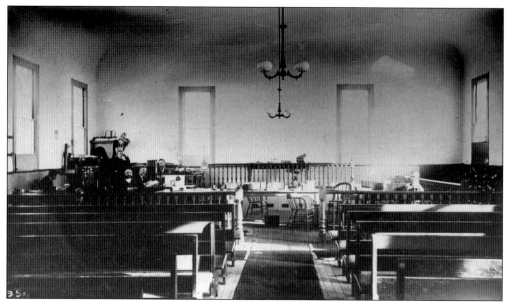

COURTHOUSE SAVED! Few buildings in the central business district were saved. The King County Courthouse was one. Judge Hanford was trying a murder case in this courtroom (above) when the Great Fire started. He kept court in session until he could see the flames from Trinity Church (page 54). Inside the courtroom are, from left to right, W. Ludlow, Constable Mills, unidentified, and Reverend Ludlow. The building, on Third Avenue and Yesler Way (below), was built in 1860. It served as a temporary public school as well as the King County Courthouse. The city purchased the building for its city hall in 1891. There were so many additions and changes that it was dubbed the "Katzenjammer Castle." After miraculously surviving the Great Fire of 1889, it was demolished in 1940. (SPL 5199; UWSC Hamilton 6/1267.)

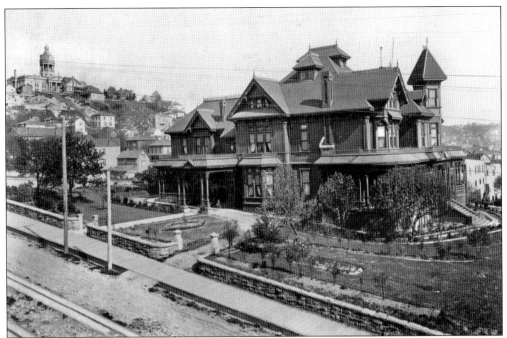

YESLER HOME SAVED! Henry and Sarah Yesler had moved up considerably from their 1860s home (see page 25) when Yesler built this 40-room mansion in his wife's orchard in 1883 at Third Avenue and James Street, the current location of the King County Courthouse. Under the cover of wet blankets and rugs, Yesler's mansion steamed but did not burn as buildings all around succumbed to the fire. When Henry passed away in 1892, his second wife donated the home for use as the first public library. In the photograph above, notice the old King County Courthouse with the crown top in the background. Having survived the Great Fire of 1889, the Yesler Mansion (now the Seattle Public Library) went up in smoke in 1901. (SPL 15231; MOHAI 1988.33.1.)

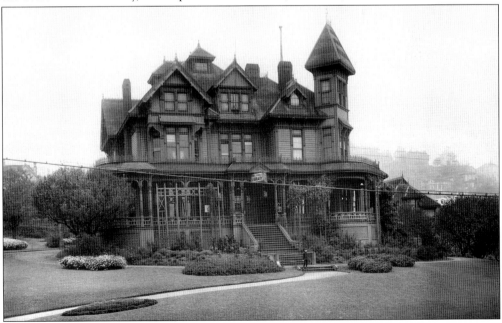

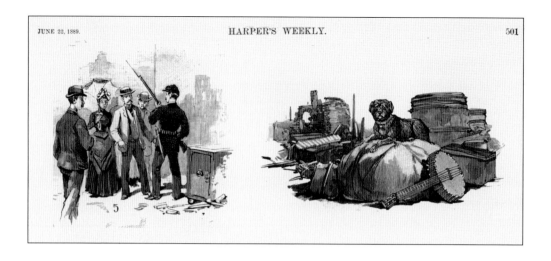

HARPER'S WEEKLY, **1889.** As the fire spread, it became apparent that the business district was doomed. Historian Murray Morgan writes, "Businesses and home owners began to empty their building of everything movable. Household goods were piled on street corners. Wagons loaded with goods rumbled over the plank streets. Those who couldn't hire wagons—most of the express men kept their charges down, although bids were reported to run as much as five hundred dollars for a single half-mile trip—carried what they could on their backs. Mayor Moran declared martial law, and asked the militia be called out and swore in a Home Guard. Thousands fled the city. Others came from miles around to help fight the fire or just watch it." The next day, Seattle awoke from a business district that just the day before had been a center bustling with commerce, industry, residents, and tourists to a business district in charred, smoldering ruins (below). What had taken nearly four decades to build had literally vanished overnight! (SPL, *Harper's Weekly*; UWSC 11996a.)

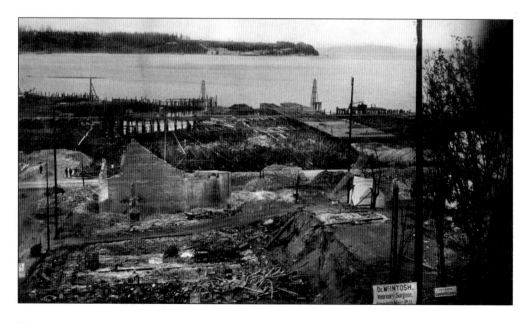

Five

RISE LIKE A PHOENIX

After the Great Fire of 1889, Seattleites, ever visionaries, got to work immediately to rebuild and reinvent their city. They took this opportunity to fix a few things that had not worked quite right on the first go-around: streets, building codes, water supply, storm water, and wastewater service.

The population growth between 1852 and 1889 led to traffic gridlock; horses, carriages, wagons, and streetcars competed for limited space on narrow streets. This, combined with the unnatural street layout from the original 1852 plat dispute between Doc Maynard and Arthur Denny, led the city council to re-plat the street grid.

The pioneers also dealt with the pesky plumbing issue that plagued the city every time a toilet flushed. Seattle was built so close to the shoreline that, when the tides of Puget Sound came in twice each day, the hydraulic grade of water flow went the wrong way. Instead of flowing out of the buildings, the tidal forces brought Elliott Bay into the plumbing fixtures. Seattle's solution to the flushing problem was simple: raise the elevation of the city. This was accomplished by increasing the street elevation during rebuilding, ranging from 10 to 40 feet.

The pioneers took this opportunity to improve the water supply and pressure, which had contributed to the severity of the great fire. A public vote held soon after the June 6, 1889, fire overwhelming supported the creation of a publicly owned water supply, Seattle Water Department (now called Seattle Public Utilities).

Seattleites resolved to build fireproof buildings and banned wooden structures. New building codes were adopted, and with the help of several architects, including Elmer Fisher, John Parkinson, Charles Saunders, and E. W. Houghton, Pioneer Square got an elegant new lease on life. The large number of buildings designed in a short period of time by a handful of architects and designers resulted in a unique harmony of Richardsonian Romanesque style in the Pioneer Square neighborhood. More jobs were created by the fire than were lost, and Seattle's rebuilding efforts resulted in another population and economic boom. Seattle's population grew to 42,837 by 1890.

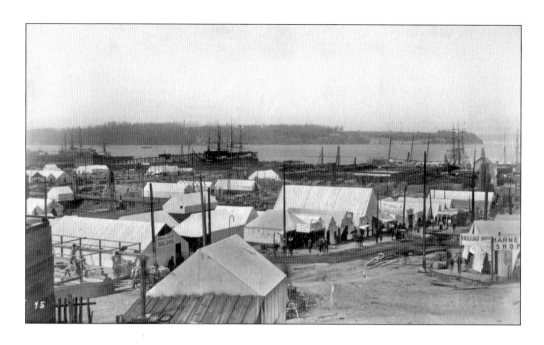

TENT CITY. Ashes were still warm and the smell of acrid smoke hung in the air as Seattle pitched tents and began to rebuild. The day after the fire, over 600 Seattle businessmen met and realized that this disaster was actually an opportunity to reinvent, alleviate past problems, and position Seattle for its future. Slogans like "Let's Pull Together" and "Rise like a Phoenix" were the mantra of the time. The *Seattle Post-Intelligencer* reported that the future vision for the area south of Mill Street (Yesler Way/Skid Road) would "never again need this section be used for despicable purposes." Ironically, some of the first businesses in tents in Pioneer Square included saloons, brothels south of Skid Road (above), and the media (below). (SPL 14605; UWSC BAB41.)

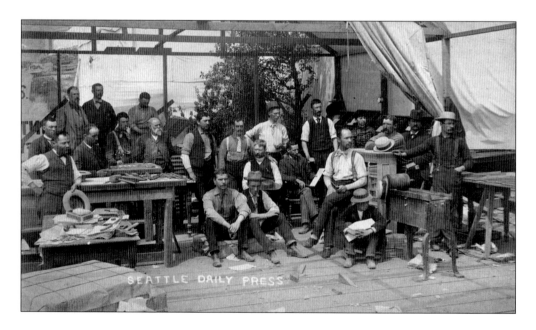

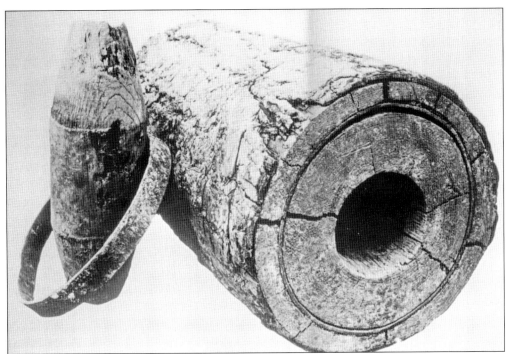

PERPETUAL PROBLEMS. Seattle's Pioneer Square had been chronically plagued with basic infrastructure problems: water, sewers, roads, buildings, and drainage. Significant public policy decisions were made in 1889 to address these problems. A public vote overwhelmingly approved a new public water supply to replace wooden pipes (above) and improve public water service. Daily tides played havoc with indoor plumbing. Newspapers helpfully printed daily tidal charts so people could plan their time of "necessity" or risk getting flushed by the tide. Sanitary facilities (right) were built up as high as 10 feet with stair access to help mitigate the tidal influence. City council passed ordinances to elevate the city from 10 to 40 feet to help with the plumbing problem, modify the street grid to help alleviate traffic congestion and improve flow, and prescribe building materials for fire safety. (J. Keniston-Longrie; Seattle Municipal Archives 50355.)

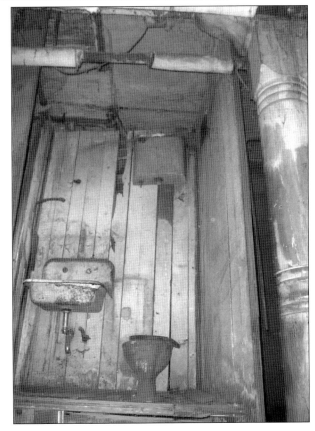

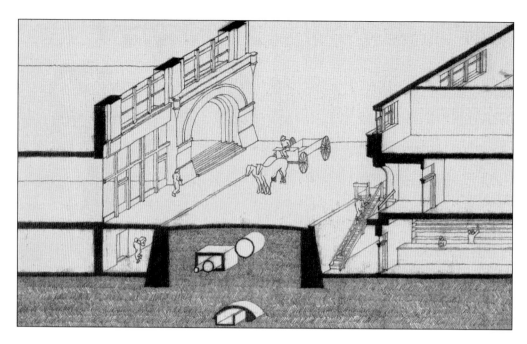

ELEVATING PIONEER SQUARE. The diagram above illustrates how Seattle engineers planned to elevate the streets and keep areaways open for private businesses. The image below shows the triangular footprint of the parcel on which once stood the Occidental Hotel, which was rebuilt as the Seattle Hotel after the fire. Walls are being constructed to hold fill in the street right-of-way, while the original grade became the lower level of businesses, which in turn became "Underground Seattle." The fire created a building boom, resulting in Seattle's population growing from 31,000 in 1889, prior to the fire, to 42,837 just a short year afterward. (Bill Speidel's Underground Tour; UWSC SEA2461.)

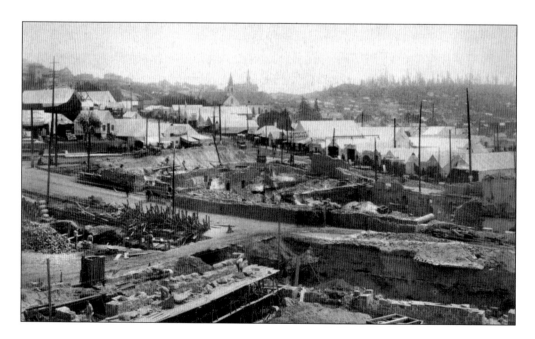

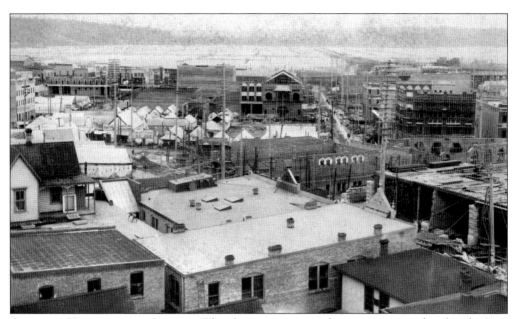

CREATING UNDERGROUND SEATTLE. The above image was taken just two months after the June 6, 1889, fire. The amount of reconstruction already taking place in just a short two months is remarkable. The rapid rate of reconstruction required building owners to plan for and create two levels of business: temporary entrances on the original grade of the land and a permanent entry at the new street grade one floor higher. For the first several years, the public walked up and down stairs to access businesses. Steep drop-offs and long skirts reportedly resulted in nearly 900 injuries from falls associated with public access to Underground Seattle. Areaways (walkways that are part of Underground Seattle today), seen below, were original sidewalks between the private buildings and street fill. (UWSC SBAB02; Seattle Municipal Archives 158551.)

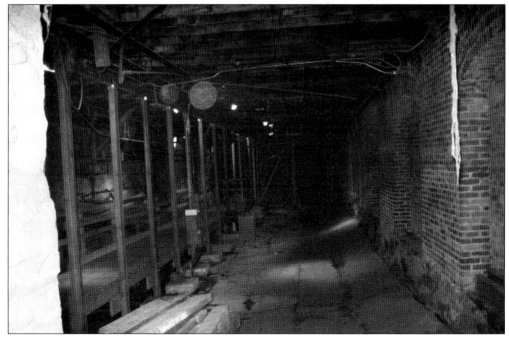

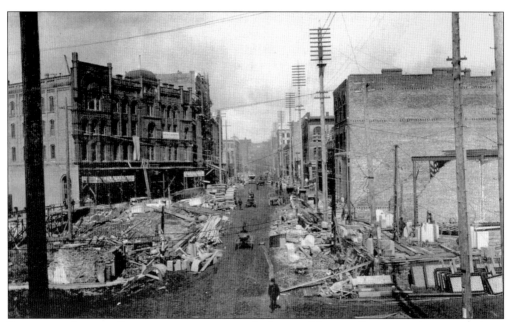

BUILDING A LEGACY. Construction progress in the heart of Pioneer Square can be seen in these two 1890 images. Both images look north on First Avenue (Front Street) from James Street and Yesler Way (Mill Street/Skid Road). By 1890, these roads had been filled and elevated to their present levels. Above, the Pioneer Building had the underground level built with today's street level just beginning. Notice what could be areaway skylights stacked along the southern edge of the Pioneer Building foundation. The image below illustrates construction progress on the street-level floor of the Pioneer Building. Considerable building debris and construction staging is located in the area that is now the pergola. Congested roads were shared by horse, man, wagon, and streetcar. The Starr-Boyd Building is on the left side in both images. (Tacoma Public Library 1302-33201; WSHS King County Fire-7.)

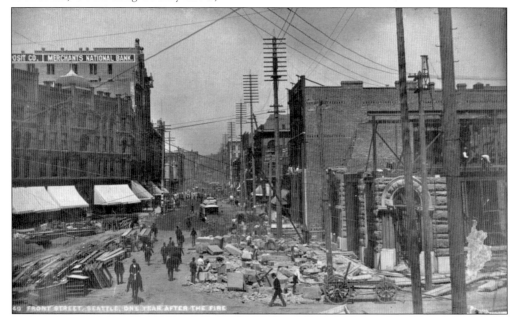

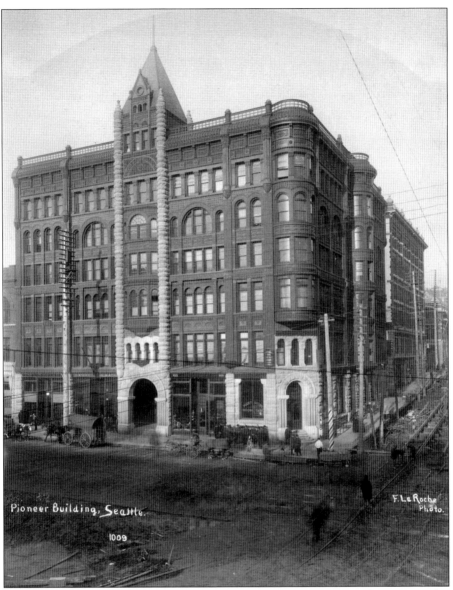

Pioneer Building, Seattle.

1009

F. Le Roche
Photo.

PIONEER BUILDING. The Pioneer Building, at the confluence of Front Street (First Avenue), James Street, and Yesler Way (Mill Street/Skid Road), was completed in 1891. Designed by Elmer Fisher in the Richardsonian Romanesque style, it is built of stone, red brick, terra-cotta, and cast iron. Fisher designed over 50 buildings during the reconstruction after the Great Fire of 1889. The building, owned by Henry Yesler, originally housed a bank and provided prestigious office space for many businesses. Sidewalks with areaway skylights had been constructed and were in use at the time of this photograph. James Street, at right, is under reconstruction, including streetcar tracks. The sidewalk curb delineates the location of the walled-off space between Underground Seattle and the street-fill to elevate the city. The Pioneer Building is located where Chief Sealth's Duwamish tribe had several longhouses. This was also the location where Henry Yesler built his first home, just east of Yesler's Mill and Cookhouse. Prior to the fire, this was near the site of the beautiful Victorian Yesler-Leary Building, constructed in 1884 (see pages 31 and 47). (UWSC LAR191.)

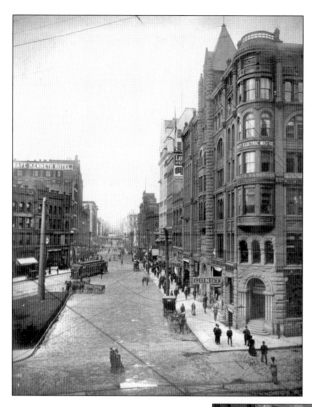

PIONEER SQUARE AND PIONEER BUILDING, 1899. This view of Pioneer Square looking north on First Avenue (Front Street) illustrates the completed product. The areaway skylights are clearly visible in the sidewalks in front of the Pioneer Building (left). Pioneer Place Park, the Totem Pole, and Chief Sealth Water Fountain can be seen by the horse and wagons in the center. The Front Street Streetcar is in operation. The image below shows the elegant interior of the Pioneer Building. (WSHS Curtis 69-25; John Stamets.)

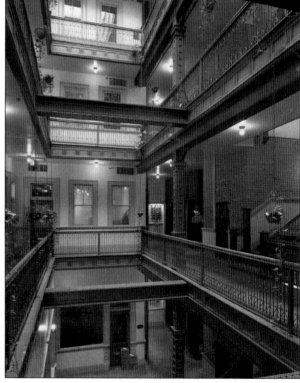

LOWMAN AND HANFORD BUILDING.
Temporarily located on Third Avenue
and James Street, the Lowman and
Hanford Building was rebuilt next to
the Pioneer Building on First Avenue
and Cherry Street (right). Founded
by James Lowman and Clarence
Hanford in 1882 as a stationery and
publishing company, it expanded into
bookbinding and sales. The company
diversified in 1897 to sell goods to gold
miners on the way to the Klondike.
The Howard Building is on the far
left, next to the Lowman and Hanford
Building. The interior image below
shows workers on a linotype machine,
invented in 1884 for line casting in
printing businesses; the linotype
revolutionized printing shops. (UWSC
WAR0143; MOHAI 1970.5046.15.)

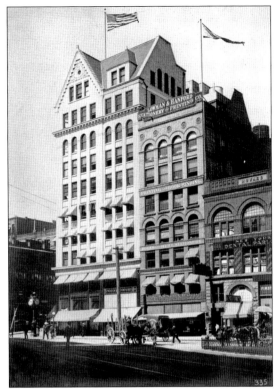

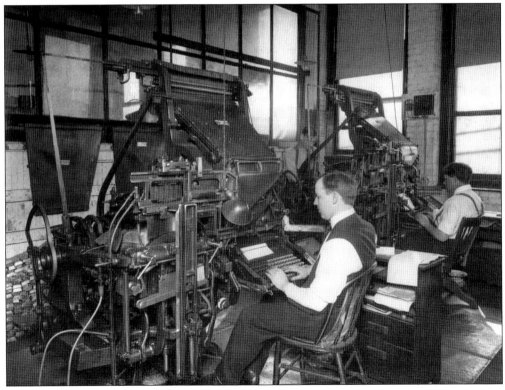

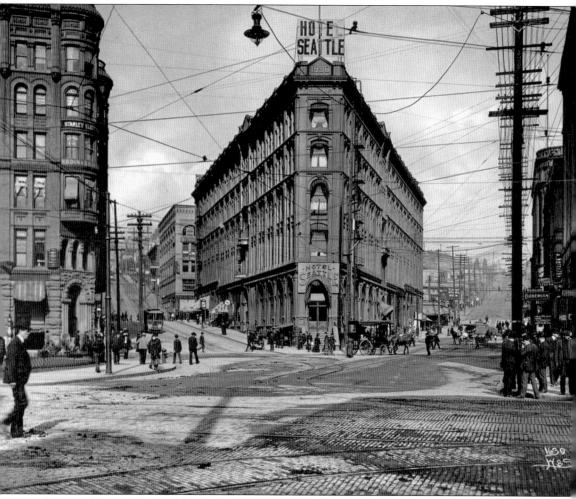

SEATTLE HOTEL. The Seattle Hotel was completed in 1890 at the awkward intersection of James Street on the left; Yesler Way (Skid Road/Mill Street) on the right; and Front Street (First Avenue/Commercial Street) in the foreground on the left, at the heart of Seattle's Pioneer Square. The Seattle Hotel boasted 200 well-appointed rooms and was close to the railroad station, docks, streetcar lines, and the center of the business district. The hotel was rebuilt on the location of the new Occidental Hotel, which was destroyed in the 1889 fire (see pages 27, 30, 31, and 60). This is the same location where the old Occidental Hotel was located (page 31) and the Mercer girls (pages 35–37) were hosted when they first arrived in Seattle in the 1860s. This is also near where the Duwamish/Suquamish longhouses once stood prior to the arrival of European explorers. The Seattle Hotel served as one of Seattle's Pioneer Square icons for decades. (MOHAI 2002.48.883.)

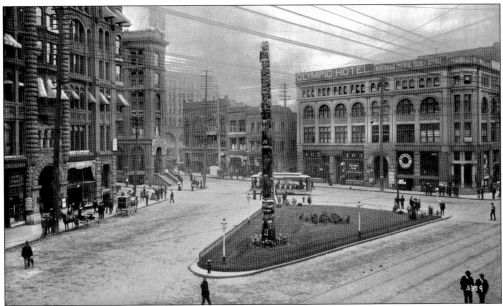

OLYMPIC BLOCK, SCHWABACHER, AND MUTUAL LIFE. Rising like a phoenix out of the ashes, Pioneer Square found itself surrounded by architecturally beautiful buildings unified by the Richardsonian Romanesque style. Directly north of Pioneer Square, the Olympic Block (above) also rose from the ashes. Edwin Houghton designed the Olympic Block in 1890; it was built on the corner of First Avenue (Front Street/Commercial Street) and Yesler Way (Mill Street/Skid Road) and housed Cooper and Levy Outfitters, Klondike Suppliers, and the ticket and baggage offices of the Northern Pacific Railroad. Across Yesler Way is the Schwabacher Building (below). The Mutual Life building on the right is under construction, with just the first floor complete. The crowd in the streets reflects the importance of Pioneer Square, as throngs of people watch an 1891 parade in celebration of President Harrison's visit to Seattle just shy of the two-year anniversary of the 1889 fire. (WSHS 1943.42.3379; UWSC CUR982.)

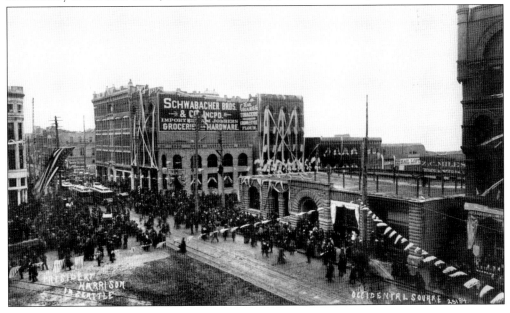

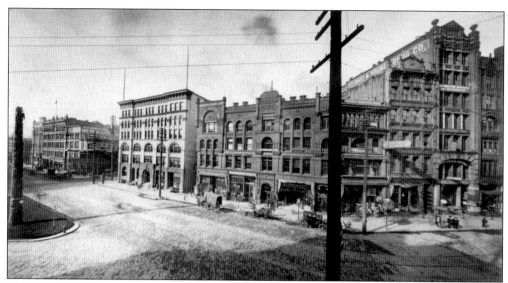

YESLER BUILDING AND STARR-BOYD BUILDING. The Yesler Building (above), designed by Elmer H. Fisher, stands kitty-corner from the Olympic Block west of Pioneer Square. Later called the Mutual Life Building, it was one of the most elegant office addresses in town and provided First National Bank of Seattle its first home. It is the site of the original Yesler Cookhouse (page 22) and at the same location as the Duwamish longhouse (page 14). The Starr-Boyd Building (below), designed by Elmer H. Fisher and built in 1889, was across First Avenue (Front Street) from the Pioneer Building and the Lowman and Hanford Building. South of the Starr-Boyd Building is the completed Mutual Life Building; north are the Safe Deposit Building and Gordon Hardware (all of which is a parking lot today). (WSHS Curtis 69/20; UWSC WAR0148.)

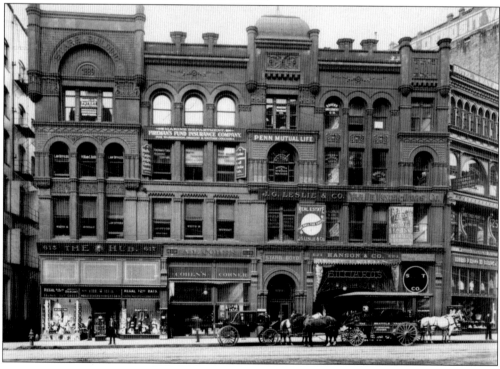

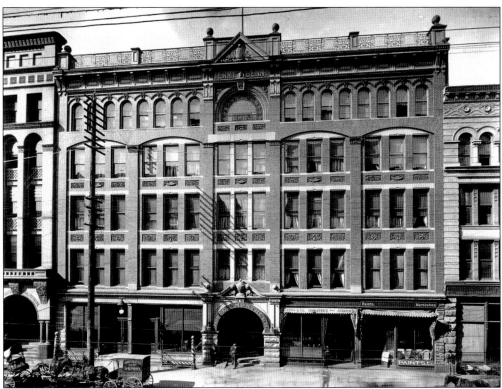

TERRY-DENNY BUILDING. Designed by Saunders and Houghton Office in the Richardsonian Romanesque style and completed in 1890, the Terry-Denny Building occupies the west side of Commercial Street (First Avenue South) between Washington Street and Yesler Way (Mill Street/Skid Road). Also known as the Great Northern Hotel, it housed miners and loggers on their way to Alaska. The building is named after pioneers Arthur Denny and Charles Terry. (MOHAI 1988.33.309.)

MAYNARD BUILDING. Originally the Dextor Horton Building, the Maynard Building was designed by Albert Wickersham in 1892 to house the Dextor Horton Bank. Dextor Horton arrived in Seattle via covered wagon in 1853. He worked at Yesler's Mill, started a general store, and began his informal banking business by hiding sacks of money in food barrels. He eventually established Seattle's first bank, Dextor Horton. (UWSC CUR235.)

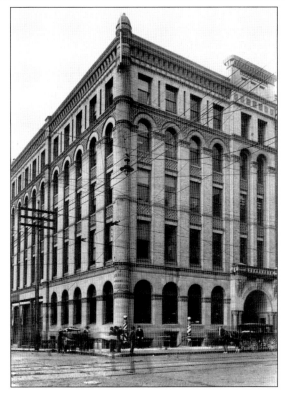

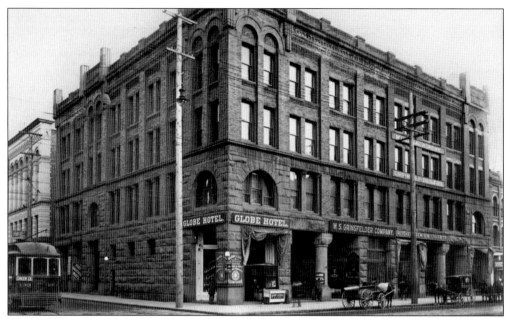

GLOBE HOTEL. Located at First Avenue South (Commercial Street) and Main Street, the Globe Hotel had retail stores on lower floors. This is the site of Seattle's first hospital, founded by Doc Maynard, and later the Arlington Hotel (page 28) until it was destroyed in the 1889 fire. The Globe Hotel played a significant role providing lodging during the Klondike gold rush and today is home to the Elliott Bay Bookstore. (UWSC CUR172.)

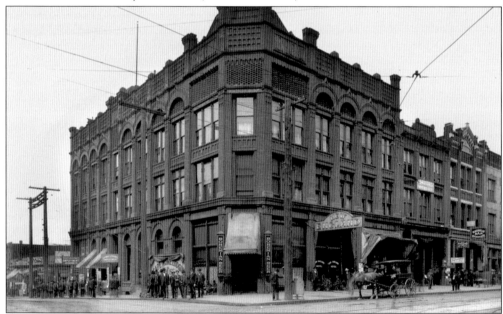

NEW ENGLAND HOTEL. Across the street from the Globe Hotel on First Avenue South (Commercial Street) and Main Street, the New England Hotel was built in 1889 and was designed by Elmer H. Fisher for Margaret Harmon to replace the original New England Hotel, which was destroyed by the 1889 fire. This location is where Doc Maynard built the second log cabin in Seattle's Pioneer Square in 1852. (MOHAI 1983.10.7368.)

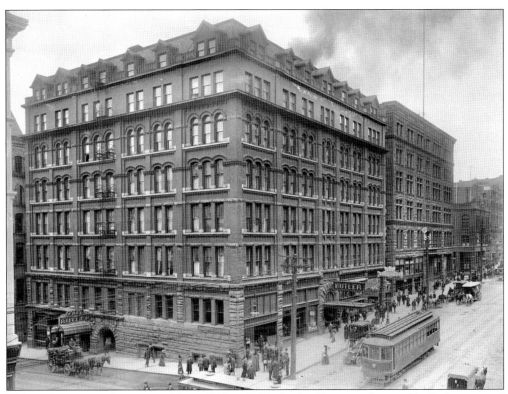

BUTLER BUILDING. Constructed from 1889 to 1890, this building was designed by Parkinson and Evers and was originally called the Parkinson and Jones Building. In 1894, it was converted to the Butler Hotel, and it was considered one of Seattle's most elegant hotels. President Garfield is said to have stayed here. The Butler Hotel's Rose Room became a front for speakeasies during Prohibition. (WSHS 1943.42.13200.)

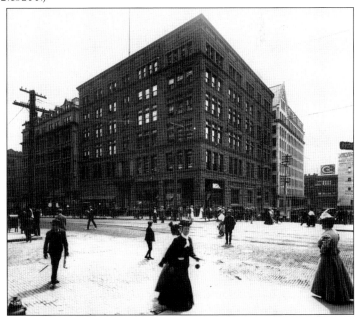

BAILEY BUILDING. Designed by Saunders and Houghton for William Elder Bailey, the Bailey Building was also known as the Harrisburg Building. Located on Second Avenue and Cherry Street, the building housed various railway and steamship companies. It was bought by Henry Broderick in the 1930s for a real estate office; his name still appears on the building. Today it houses a Seattle's Best Coffee shop. (UWSC CUR461.)

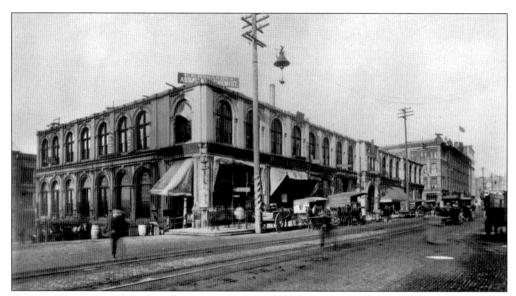

COLMAN BUILDING. The original two-story Colman Building (above), designed by Stephen Meany, was erected by James Colman, who arrived in Seattle in 1865. Colman was a major promoter of the Renton Coal mines who also operated a railroad for a year, among other business ventures. The Colman Block is built on the remains of the ship *Winward* (page 81). In 1904, Danish architect August Tidemand remodeled the building and added several floors (below). The Colman Building, at 811 First Avenue between Columbia and Marion Streets, housed grocer Louch, Augstien, and Company, as well as the Klondike outfitter Rochester Clothing Company. Later it housed offices for the Alaska-Yukon Pacific Exposition. (UWSC SEA2689; UWSC CUR569.)

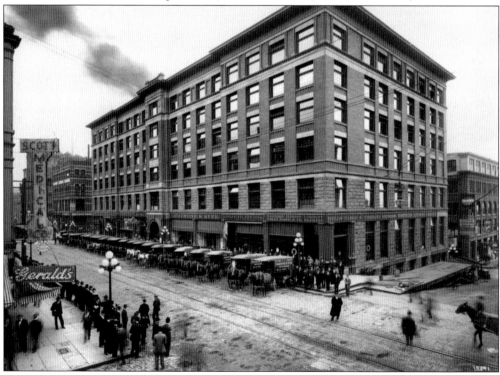

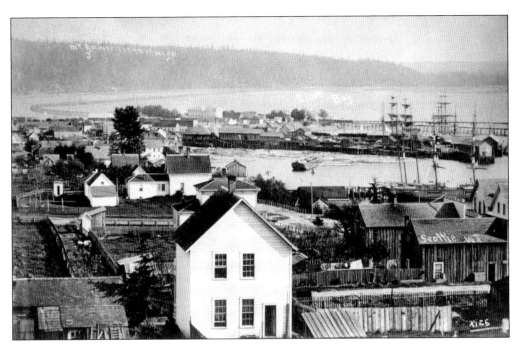

BURIED TREASURE. The ship *Winward* wrecked near Whidbey Island in 1875. James Colman had the ship towed to Seattle, intending to salvage it. The *Winward* sat 150 yards offshore in Elliott Bay for many years, and when the Colman Block was constructed at First Avenue and Columbia Street (page 80) after the 1889 fire, the ship and bay were filled with soil and buried under the foundation. The 1878 view of Pioneer Square above, looking south, clearly shows the *Winward* moored in Elliott Bay just north of Yesler's Wharf. The image below looks west across Elliott Bay with the Olympic Mountains in the background and the *Winward* in the foreground. This illustrates how drastically the environment and landscape have changed from the original island that was Pioneer Square to the urban landscape of today. (SPL 22835; WSHS Curtis 59757.)

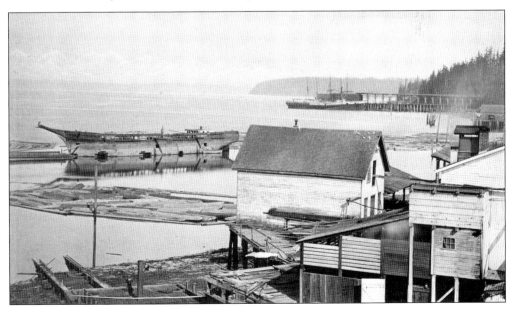

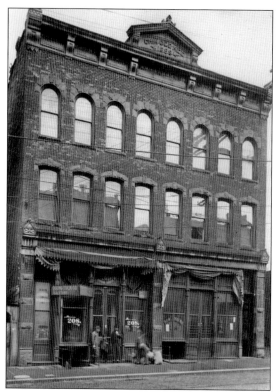

CHIN GEE HEE. The Chin Gee Hee Building at 400 Second Avenue Extension was built in 1890 and designed by W. E. Boone, a descendant of Daniel Boone. Chin Gee Hee founded the Qun Tuck Company, a labor contracting and import/export firm. Seattle's Chinatown, located in Pioneer Square, was densely populated. The Chin Gee Hee Building (labeled Hop Sing on Doug and Art Chin's map, page 83) is the last of the original Chinatown buildings. The rest were demolished during the extension of Second Avenue. The building below was modified after this picture as a result of the extension. Per the Chins' map, the building was used by the Hop Sing Society, a family association established in the 1870s and originally located at First Avenue and Mill Street (Yesler Way/Skid Road). Seattle's early Chinese community revolved around the Wa Chong Company at Third Avenue and Washington Street in Pioneer Square. (UWSC CUR1692; MOHAI 1986.5.7828.1.)

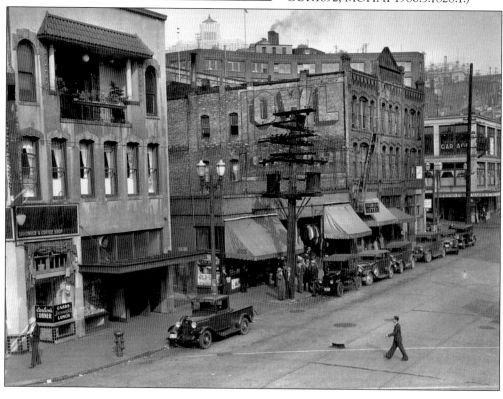

CHINATOWN AND JAPANTOWN. Pioneer Square has always been a very diverse community. The map at right by Doug and Art Chin from *Uphill* illustrates the original Chinatown that was in Pioneer Square. The Second Avenue Extension in the 1920s, combined with the Jackson Street regrade, pushed much of the original Chinatown and Japantown to what is now known as Seattle's International District to the east and south of Pioneer Square. The image below is of the Furuya Building in the shadows of Smith Tower. The M. Furuya Company was one of the largest Japanese businesses in Seattle, starting with groceries and expanding to art and banking. Furuya, a hardworking businessman, became a millionaire. (Doug and Art Chin; MOHAI 1999.098.270.)

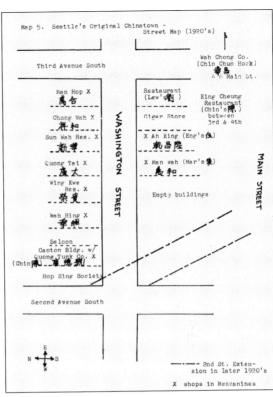

Map 5. Seattle's Original Chinatown - Street Map (1920's)

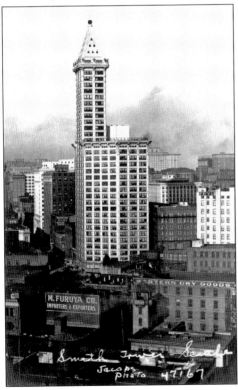

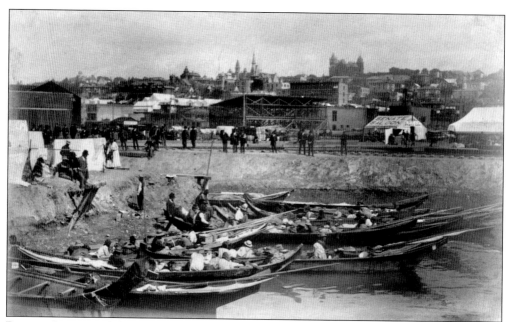

BALLAST ISLAND. While areas north of Yesler Way (Skid Road/Mill Street) received a magnificent makeover, areas to the south did not. Native Americans continued to be banned from living in the city or on city land and were relegated to an area made from ballast fill deposited by sailing ships and known as Ballast Island. The Native Americans lived in canoes, tents, and makeshift housing trying to survive. (UWSC NA680.)

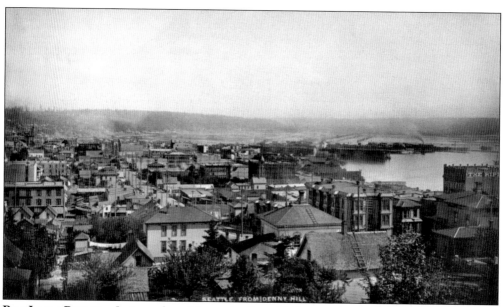

RISE LIKE A PHOENIX. In just a short 24 months, Seattle's Pioneer Square rose like a phoenix from the ashes. Over 125 acres—30 city blocks—that lay charred from the fire of June 6, 1889, had been transformed into a magnificent bustling metropolis. The shear magnitude of change and human effort was truly amazing. Seattle's spirit had turned a disaster into a golden opportunity. (SPL 5160.)

Six

GOLD!

In July 1897, the SS *Excelsior* headed for San Francisco and the SS *Portland* arrived in Seattle laden with gold. The July 17, 1897, *Seattle Post-Intelligencer* headlines read "GOLD! GOLD! GOLD!", quickly spreading the exciting news. Thousands rushed to Seattle's docks cheering the SS *Portland*, her passengers, and her golden cargo.

Seattle mined the miners with the 1858 Fraser River gold rush; in 1864 with the Boise, Idaho, gold rush; and yet again with the 1878 Sultan River gold rush. However, the most important gold rush to Seattle came after the 1893 panic caused by bank and railroad failures with the 1897 Klondike gold rush.

The Canadian requirement of one year of provisions per person entering the country, Seattle's previous gold rush experience, and the city's geographic location positioned Seattle perfectly for the Klondike gold rush market. The Seattle Chamber of Commerce, lead by Erastus Brainaird, was quick to establish Seattle as the premier Klondike outfitter for the gold seekers, point of departure, and the "Gateway to Klondike."

Within six weeks of the historic landing of the SS *Portland*, Seattle was a boomtown. Not only did Seattle provide supplies, lodging, entertainment, and transportation for the estimated 100,000 prospectors en route to the Klondike goldfields, but Seattle quickly established services to assist the gold miners on their way back from the goldfields with an assay office and other services. Many of the returning gold miners landed in Seattle and never left.

Several of the returning gold miners who stayed in Seattle founded businesses that are still vital to the local, regional, and national economy over a century later. These businessmen include John Nordstrom (Nordstrom's), George H. Bartell (Bartell Drugstore), and Alexander Pantages (Pantages Theater).

Seattle's population grew from 42,837 to 237,194 from 1890 to 1910 as a result of the Klondike gold rush and the Spanish-American War. As the population grew, Seattle's economic base diversified, resulting in long-lasting impacts to the city that continue to the present.

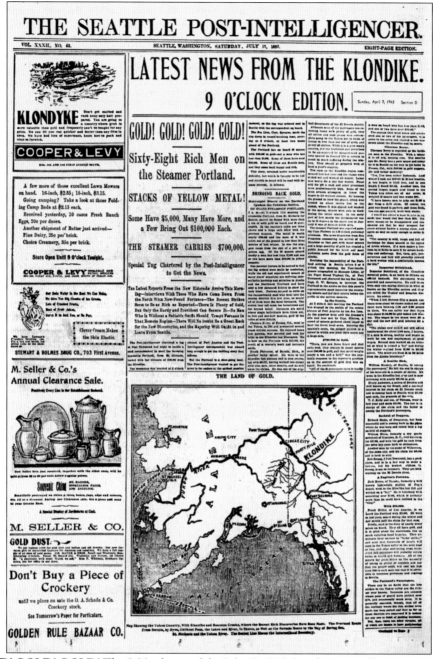

GOLD! GOLD! GOLD! The 9:00 edition of the July 17, 1897, *Seattle Post-Intelligencer* trumpeted the discovery of gold in Alaska. This marked the end of the 1893 depression suffered in Seattle and the beginning of an exciting boom time. Virtually overnight, Seattle's leaders, entrepreneurs, and businessmen were either themselves on the way to the Yukon or were taking action to help those on their way. Due to geographical location, transportation by rail and sail, and a keen chamber of commerce leader in Erastus Brainaird, Seattle was set to make a mint off the miners en route to and from the Yukon. Seattle's Pioneer Square was considered the "Gateway to Klondike." (MOHAI 19084.)

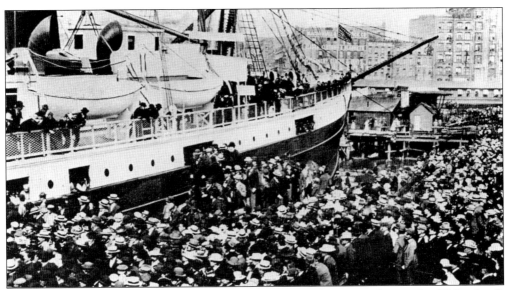

RAILS AND SAILS. Thousands thronged to Seattle's waterfront to welcome the SS *Portland*'s passengers, crew, and golden cargo to Seattle. Thousands more rushed to book transport north to try their luck at striking it rich (above). Seattle, the largest port close to the Klondike, was well positioned as a transportation hub, with the Northern Pacific Railroad connecting it to the rest of the continental United States. The Northern Pacific Railroad depot is pictured below; thousands of people traveled through this train depot en route to the Klondike, seeking their fortunes in gold. (MOHAI 12757; MOHAI SHS2446.)

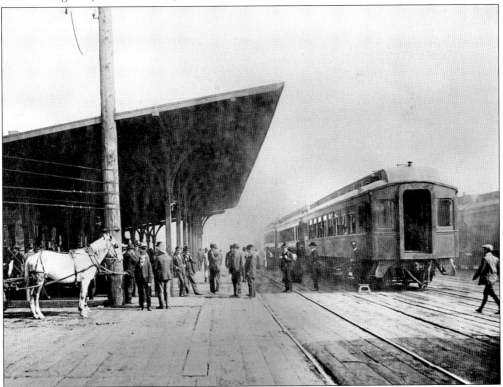

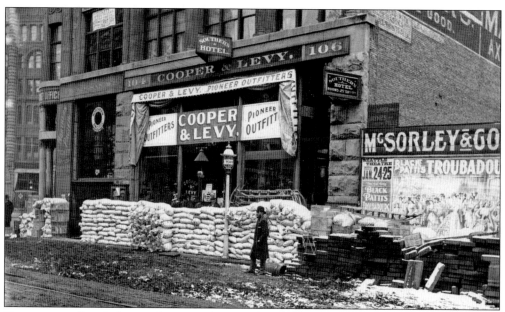

OUTFITTING. Seattle knew what it took to outfit a gold miner. Canada required one year of provisions per person entering the country; this positioned Seattle perfectly for the Klondike gold rush market. The volume of goods pushed the limits of the outfitters to store requisite supplies. Alaskan outfitting establishments augmented storage space by utilizing sidewalks and underground areaways. Cooper and Levy's (above), at First Avenue South and Yesler Way in the same building as the Northern Pacific Railway, played a significant role in outfitting miners on their way north, as did many other businesses in the Pioneer Square area. The John B. Agen store, located at 820–822 Western Avenue, is another example of outfitters ready to supply any item a miner might need (or not) while in the Klondike (below). These scenes were repeated throughout Pioneer Square. (UWSC SEA1334; UWSC SEA1335.)

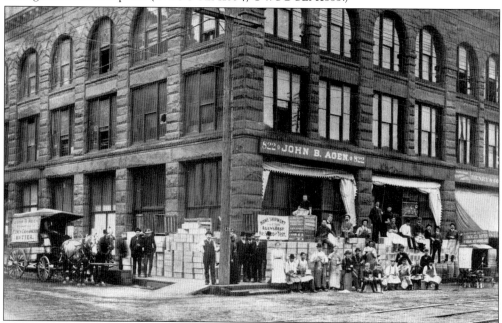

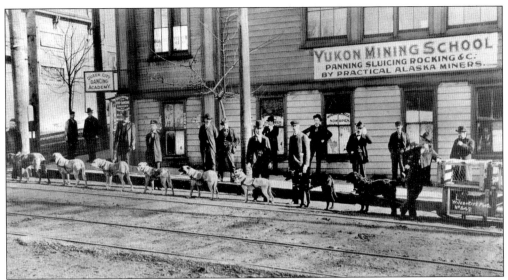

EVERY NEED MET. No need went unmet in Seattle. Dogs and dog mushing classes were available. Locals had to take extra care of their canine pals, as they disappeared at an unusually high rate. Panning and sluicing supplies, as well as instruction, were ready with immediate openings (above). Once all of the supplies were purchased and packaged, transporting services (below) were available for the miners to the ships leaving on a regular basis on the wharfs. Hotels and housing were bursting at the seams. Underground Seattle helped with the overflow. Honky-tonk bars, saloons, taverns, and other entertainment venues were busier than ever. It was not uncommon to see men 10 deep waiting with an empty mug for a refill of beer at the bar. Seattle was once again a wide-open city. (MOHAI 2704; MOHAI 2509.)

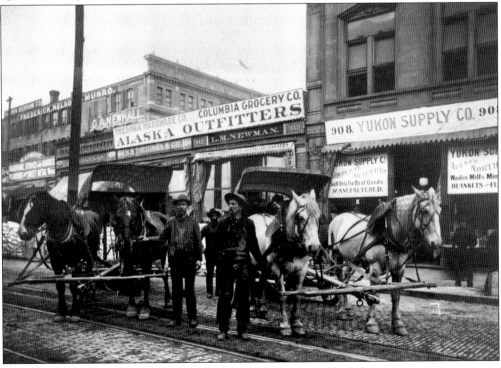

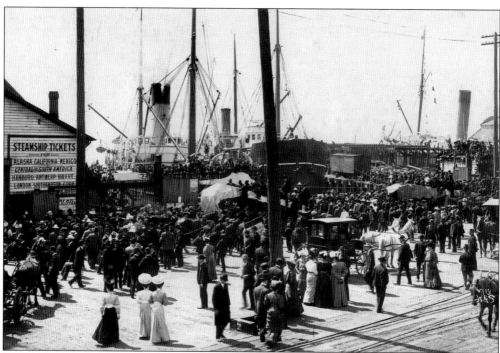

SHIPS AHOY. Ever ready with its diversified economy, Seattle not only sold ship passage to Alaska, the city built it, too. The SS *Victoria* is about to sail, and bookings north are overwhelmed (above). The Moran Brothers Shipyard saw the need and took advantage of the opportunity to commission the building of 12 steamers (below) to carry people and supplies to support the Klondike gold rush. Each vessel was 175 feet long and 35 feet wide, built for the shallow river water but sturdy enough to make the voyage up north. (SPL 226370; MOHAI 1988.33.217.)

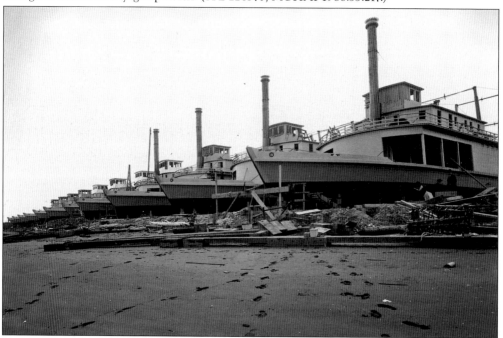

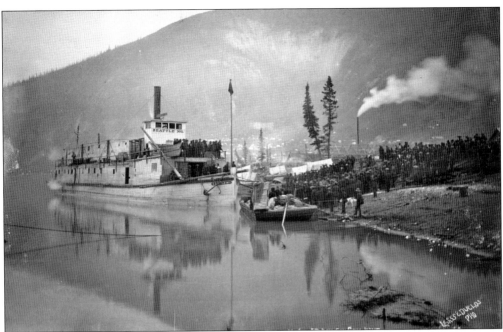

THE YUKON. The Moran Brothers Shipbuilding Company built the steamer *Seattle No. 1*, seen above arriving at midnight in Dawson City in 1898. This is the same steamer shown being built in Seattle on page 90. Due to the location and angle of the sun, during the summer months, there is very little if any darkness. Once up north, the living conditions were tough in the summer (bugs and bears) and worse in the winter (cold and snow). Few if any amenities were available, and the miner's survival depended upon whatever provisions they had outfitted themselves with prior to shipping out of Seattle. Tents, many purchased in Seattle's Pioneer Square, were the principal shelter (below). Food and cooking and other essentials also were brought from Seattle by each miner. (UWSC HEG409; MOHAI 8414.)

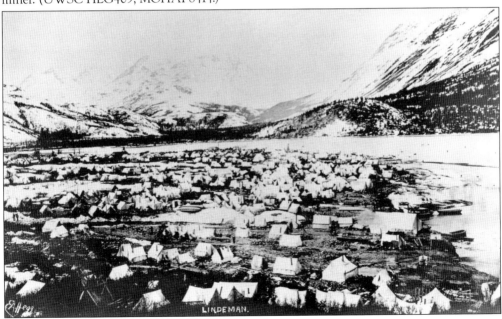

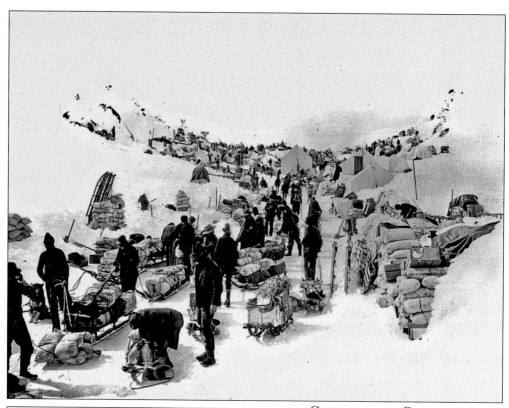

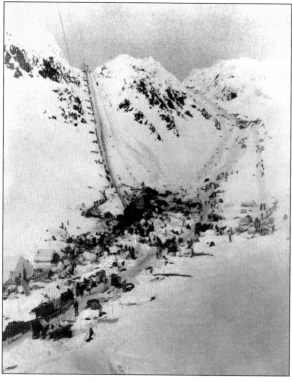

GETTING TO THE GOLDFIELDS.
Getting to the Yukon was the
easy part. Crossing the Chilkoot
Pass was one of the hardest parts.
Carrying all needed provisions for
a year added to the challenge. The
conditions were rough. Several
men (above) gather while waiting
near their supplies to cross the
pass. Much of what they wear and
have packed came from Seattle's
Pioneer Square. The Chilkoot
Pass (left) was the easiest way to
get to the goldfields; it was not
an easy task going up this steep
incline on snow and ice coupled
with 1898-style equipment, even
for the most conditioned and
prepared. Many people, horses,
and dogs became injured, ill,
or died before they even had a
chance to stake out their claim.
(MOHAI 15868; MOHAI 12370.)

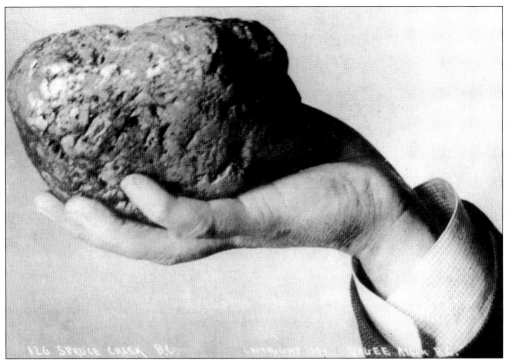

EUREKA! Those who were lucky were able to stake a claim. They spent months or years of hard labor sluicing, panning, and digging for gold, living in harsh conditions. Most came up empty-handed and with broken dreams. A few did not. The image of success was in every man's dream. The largest nugget found (above) was at Spruce Creek and weighed in at 15 grams (83 ounces. The wooden boxes of gold below, delivered to Seattle from the Klondike by the steamer *Roanoke*, contained gold valued at $4 million in 1897, a time when the going price of gold was $20.67 per ounce. (The same boxes of gold in 2009 prices, at $330.72 per ounce, would be worth $1.7 billion.) These images fueled the gold seekers' dreams and lined the pockets of Seattle's Pioneer Square businesses. (MOHAI 11959; MOHAI 367.)

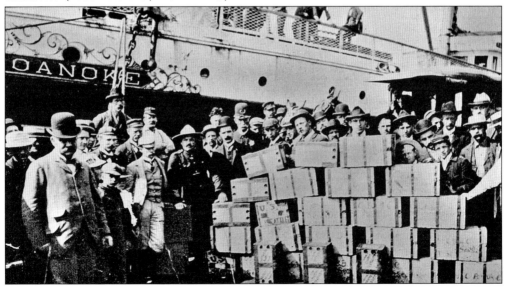

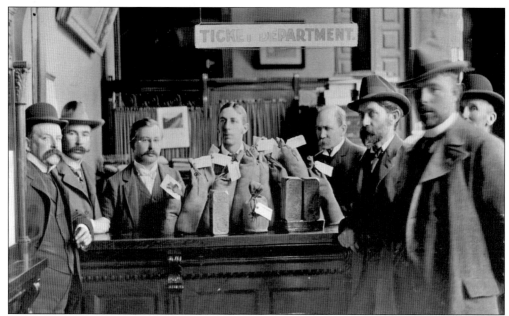

U.S. Assay Office. Ever ready to provide fully integrated service, Seattle Chamber of Commerce leader Erastus Brainaird successfully lobbied to establish a U.S. Assay Office in Seattle. Seattle's assay office was located in the Prosch Building at 617 Ninth Avenue, built in 1886 by Thomas Prosch, owner of the *Seattle Post-Intelligencer*. Gold dust and bricks are ticketed for safe keeping at the Scandinavian American Bank in Seattle above. Andrew Chilberg is the third man from the right behind the counter; the rest are unidentified. Below, University of Washington graduate Lee H. McCloy is the assayer in the Seattle Assay Office in this 1900 interior photograph. The gold dust and nuggets were melted down and made into gold bricks that were stamped by the U.S. Assay Office. (MOHAI 1230; MOHAI 404.)

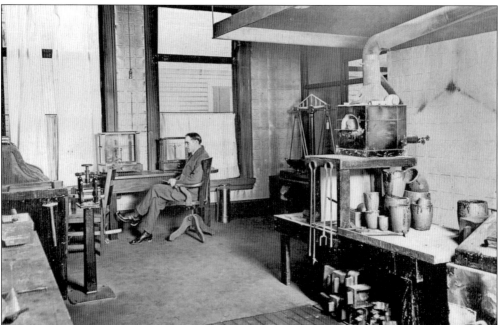

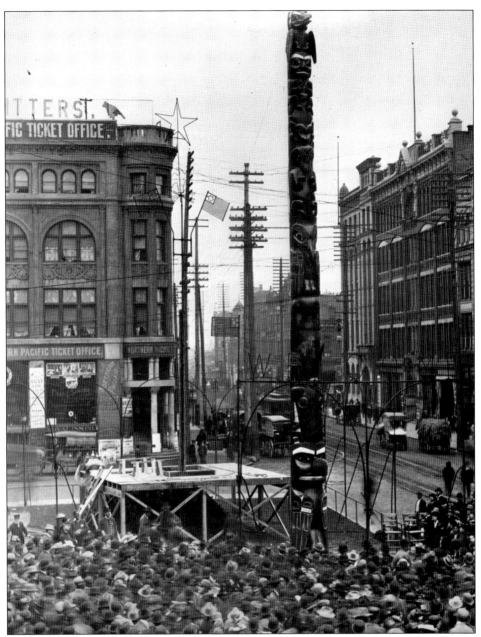

PIONEER SQUARE TOTEM POLE. The Klondike gold rush inspired many Seattleites to become more aware of Alaska, if only to appreciate the business opportunities it provided. The 100-year-old, 60-foot Tlingit totem pole arrived in Seattle's Pioneer Square in 1899 after a group of Seattle travelers stole it from a Tlingit Indian village in Tongass, Alaska. The Tlingits sued for damages and won but were awarded a lesser monetary amount. The original Tlingit totem pole was damaged by vandalism in 1938; however, the federal government commissioned Tlingit tribal members Charles and William Brown to carve a replica that stands in Pioneer Square today. It has come to symbolize the connection between Seattle and Alaska as well as the relationship between the Native American people and immigrants to the Seattle area. The pole faces north in honor of the Klondike gold rush. (Seattle Municipal Archives 29981.)

95

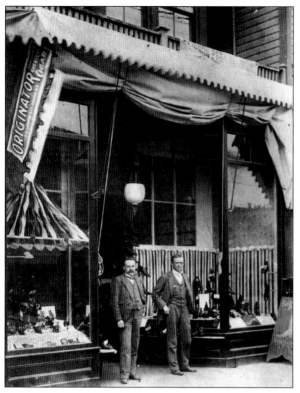

WALLIN AND NORDSTROM SHOE STORE. While most gold seekers did not find their fortune in gold, others did, and upon their return to Seattle, they liked it so much they stayed. Not only did they stay, they invested their earnings wisely and started businesses that are still alive and viable over a century later. John Nordstrom and Carl Wallin met in the Yukon, pooled their $5,000, entered into a partnership, and opened Nordstrom's Shoe Store in 1901 at 318 Pike Street, Seattle. Carl Wallin (left) and John Nordstrom (right) stand at left in their first shoe store. Four years later, they moved to 1328 Second Avenue. Below, Nordstrom (far left) and Wallin (far right) stand in the interior of the narrow showroom in 1907 with employees. (MOHAI 1986.5.12080.1; MOHAI 1986.5.12080.2.)

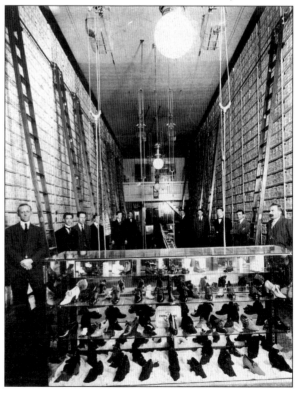

PANTAGES THEATER. Alexander Pantages participated in the Klondike gold rush in Dawson City, where he became the business partner and lover of saloon- and brothel-keeper "Klondike Kate" Rockwell, managing vaudeville and burlesque entertainment venues in Dawson City. Originally from the Greek Island of Andros, Pantages was a theatrical entrepreneur who arrived in Seattle in 1902 and operated the Crystal Theater. He created a very popular vaudeville circuit of elaborate theaters named Pantages that still stand today in several cities in the United States and Canada, including Seattle and Tacoma. Pantages invested his earnings from the Klondike in Seattle and developed a multi-million-dollar national business, competing fiercely with John Considine (see pages 42–44). (UWSC POR124; MOHAI 1893.10.8722.)

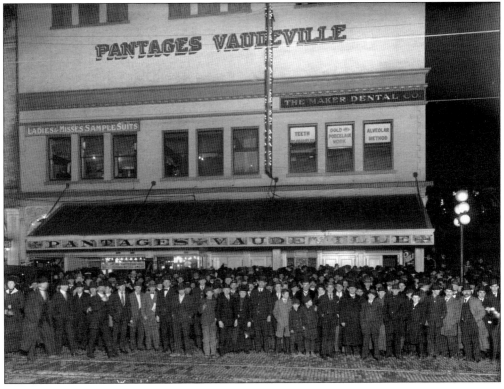

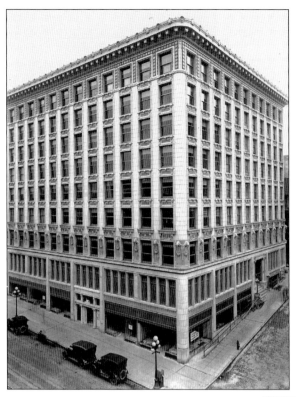

ARCTIC CLUB. Seattle residents who struck it rich in the Klondike goldfields formed the Arctic Club at Third Avenue and Cherry Street (left). Built in 1908 and designed by A. Warren Gould, the building features Alaskan marble hallways, 27 molded walrus heads, and the Dome Room with a beautiful Tiffany glass dome. Amenities include a bowling alley, a billiard room, card rooms, a roof garden, and a grand formal dining room. The outside is adorned with ornate walruses complete with tusks (below). The *Alaska Yukon Magazine* reported that the Arctic Club was "one of the most important business structures in the city." It served as a social club for veterans of the Klondike gold rush and promoted business between Alaska and the Pacific Northwest. It has been recently restored as the Arctic Club Hotel. (MOHAI 1983.10.10417; J. Keniston-Longrie.)

Seven

REGRADES AND RAILROADS

From the beginning, the vision of the founders of Pioneer Square never included the naturally hilly features of Seattle; they believed the prerequisite for commercial growth and progress was flat topography. Almost immediately, the pioneers began to reshape the natural features of the area by cutting down trees and moving dirt around, flattening the hills to fill ravines and tidelands.

With the advent of a strong economic base, a booming population, and funding in public works coffers, the City of Seattle began in earnest to reshape the landscape to provide for easier mobility of people and goods, land for building homes and industry, and a suitable place for the much sought-after railroad. Reginald Heber Thompson was appointed city engineer in 1892. Over the next several decades, Thompson regraded city streets and hills with a vengeance, moving over 80 million cubic yards of dirt. Thompson filled in vast areas of pristine wetlands and tidelands located near Pioneer Square for reclamation.

Thompson convinced James J. Hill, owner of the Great Northern Railroad, to establish his terminus in Seattle and to establish King Street Station on the reclaimed land adjacent to Pioneer Square. Eventually Seattle was able to establish not one but two beautiful train depots, King Street Station and Union Station, befitting the sophisticated city it had become. The hard-fought-for train stations and railroad lines positioned Seattle to become the regional leader in the Pacific Northwest for multimodal transportation, including shipping, rail, road, bikes, and pedestrians, which it remains today.

The achievement of the founders' vision to significantly change Seattle's landscape came with a price and unintended consequences. These major public works projects, which created Underground Seattle, tunnels, level streets, a new shoreline, and filled tidelands all took place prior to recognition of environmental impacts, environmental justice, or social equity. Thousands of acres of critical habitat for salmon, orca whales, and eagles were lost forever. Many of the species this habitat supported are either extinct or on the brink of extinction. The Duwamish/Suquamish tribe, which depended on this intricate ecosystem, lost the lagoon south of Jijilatech (Pioneer Square) for traditional and accustomed use forever.

RE-LANDSCAPING SEATTLE. These two 1900-era advertisements, "Tide Lands" and "Experienced House Mover," symbolize the major landscape changes Seattle was experiencing to implement the vision of a flat topography. Historian Murray Morgan writes, "The hills are so steep in downtown Seattle that some of the sidewalks have cleats. They used to be steeper." The significant environmental impacts, economic loses, and social injustices that were imposed upon Seattle's citizens in the name of progress are almost indescribable. Thousands of elegant (and not so elegant) residences, hotels, boardinghouses, and commercial businesses were moved, torn down, or fell down, never to be replaced. Over 1,500 acres of fish and wildlife habitat lost to reclamation can never be recovered. What took place in the early 1900s, while technically feasible, most likely would be environmentally and politically infeasible today. (UWSC ADV0366; UWSC ADV0199.)

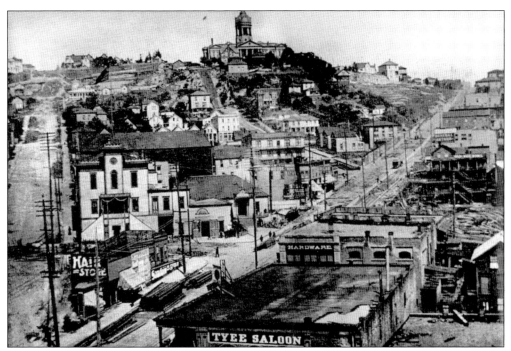

HILLS AND HORSEPOWER. Seattle had hills—steep hills—and lots of them. As Seattle grew, the population used up what little flat land there was and pushed into the surrounding hills. It did not take long for Seattleites to realize that it was difficult to travel and haul goods up and down the steep hills. The image above is a partial glimpse of Jackson Street Hill before the regrade. The lower image from the Seattle Engineering Department is a communication tool perhaps for the public or for elected officials explaining how many horses would be needed to haul an average load up a steep grade. Perhaps it was justification and reasoning for the regrade, as the automobile had not been invented at the time the regrade began. Speidel writes, "At its steepest today, Yesler Way has a 15-percent grade. When the pioneers first showed up it was a 49-percent grade." (Wing Luke Museum 1991.100.526; Seattle Municipal Archives 82.)

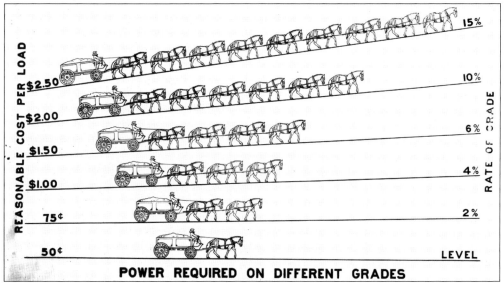

POWER REQUIRED ON DIFFERENT GRADES

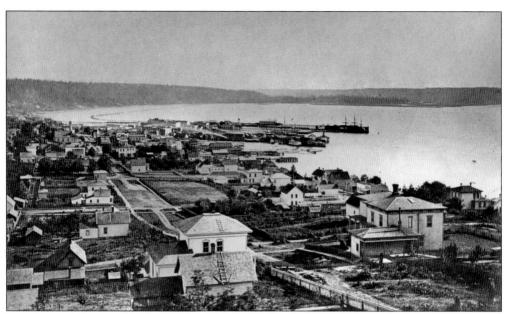

TIDELANDS SOUTH OF PIONEER SQUARE, 1878. These two 1878 images illustrate the vastness of the complex ecosystem providing fully functioning tidal lands south of Pioneer Square. Over 1,500 acres of tidelands provided food and habitat for species including salmon, bull trout, shellfish, birds, plants, and other wildlife. The Duwamish/Suquamish tribe had a synergy with the environment and understood that all things were connected. The new white settlers did not recognize or value that environmental benefit. The image above illustrates the tidelands south of Pioneer Square, and the image below is a view of the same tidelands, looking northwest from Beacon Hill. The tidelands had already been impacted by several sets of railroad trestles on pilings in the lagoon. (SPL 5112; SPL 23050.)

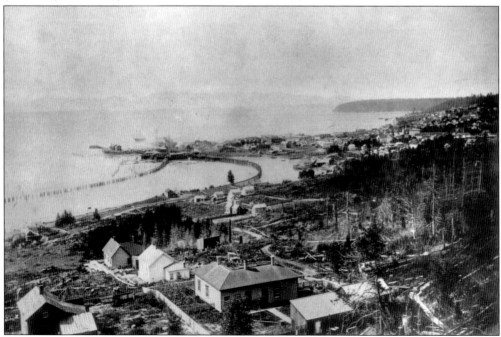

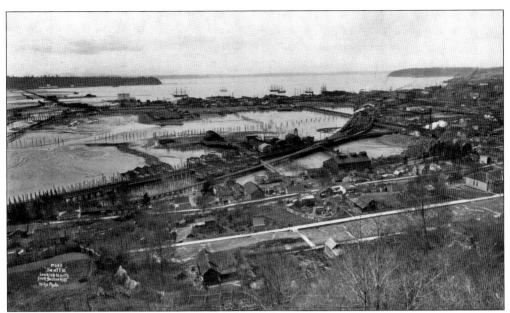

TIDELANDS SOUTH OF PIONEER SQUARE, 1900. Twenty-two years later, in 1900, the upper image shows a similar view of tidelands south of Pioneer Square, which have been more severely impacted but still exist. While not pristine, the tidelands still provided some functionality for fish, wildlife, and plant species, as well as traditional hunting and gathering lifestyles. Water quality issues were of concern due to various pollution sources. These contaminants were likely entering the food chains of various species, including humans. The lower image, looking north along a railway trestle between today's Fourth Avenue South and Sixth Avenue South, demonstrates the vastness of the tidelands that were on the brink of reclamation for supposedly higher, better uses. (SPL 22783; Wing Luke Museum 1997.29.6.)

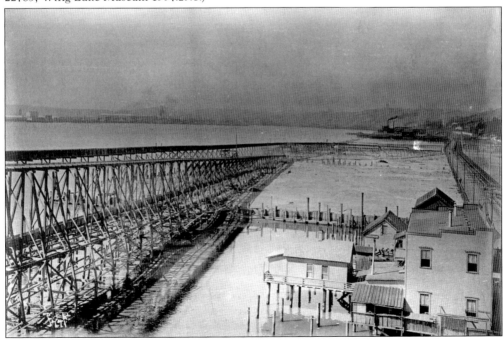

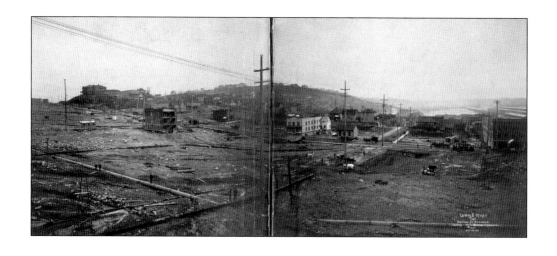

JACKSON STREET REGRADE IMPACTS. By 1908, the Jackson Street regrade was in full swing. Sluicing techniques borrowed from the mining industry were implemented by engineers. Tremendous volumes of water under significant pressure washed away the soils. In the upper image, looking south towards tidelands south of Pioneer Square, impacts to the landscape are apparent. The pipes on the ground provide the water needed for sluicing. In the image below, looking east from Weller Street, one can see on the left the difference in elevation from the regrade, which continued while homes were still in place, occupied or not. The Jackson Street Regrade began in the mid-1890s and lasted over two decades. Over 80 million cubic yards of soil were removed and deposited into once-pristine aquatic tidelands to reclaim the land for industrial use. (SPL 5594; SPL 5595.)

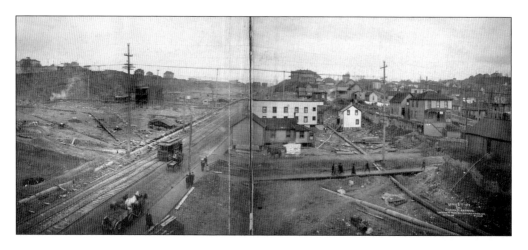

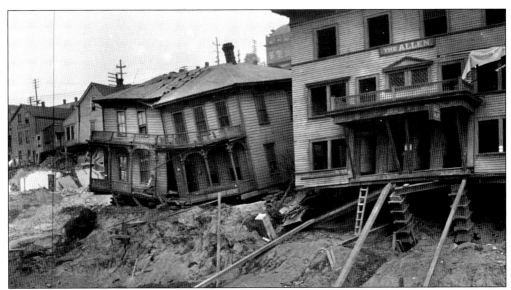

Destruction and Reclamation. The regrading and sluicing of the hills continued with a vengeance. The upper image shows the Allen Hotel on the brink of collapse with the regrade activities underway. Some of the homes were salvaged for reuse; others became part of the reclamation spoils and are buried somewhere in Seattle. The lower image shows how the regrading activities continued, even when the property was in dispute with the city, as demonstrated by the elegant large home left high and dry as the ground was literally washed away around it. Homeowners could arrange to have their home moved, or it would be buried somewhere in Seattle. (Seattle Municipal Archives 52191; MOHAI SHS 3062.)

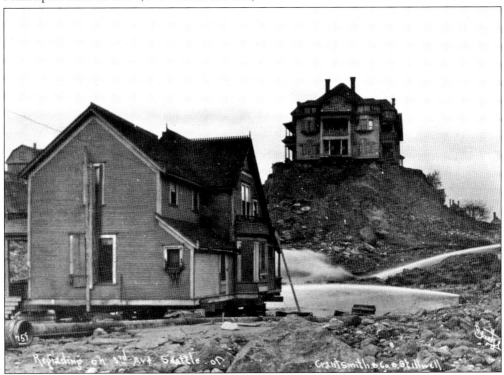

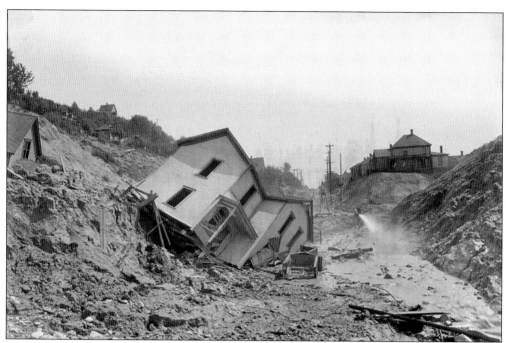

SLUICING AND RECLAIMING. The image above illustrates the sluicing activities and the fate of homes that were not voluntarily moved by the owners. Notice the erosion caused by the sluicing and the home on the far left covered with soil up to the second floor. The lower image illustrates the macro-landscape impacts of the Jackson Street Regrade, which ended up enlarging Pioneer Square via reclamation of the tide flats as well as making uplands from aquatic lands along Seattle's waterfront. (WSHS 1943.42.18029; MOHAI SEA 1214.)

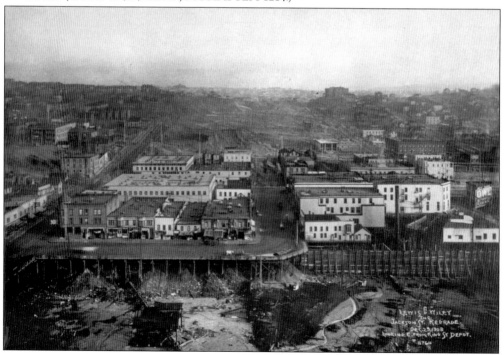

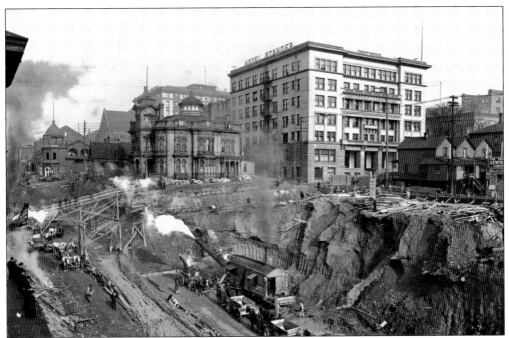

THIRD AVENUE REGRADE. Seattle's engineers were busy; at the same time they were regrading Jackson Street, they were also regrading several other downtown streets. Above is the Third Avenue Regrade at Columbia Street looking north. Third Avenue Theater is in the distance. Below is a view of the same activity looking east on Madison Street, with the Third Avenue Theater on the right. The streetcar tracks were shored to ensure service during construction. (WSHS 1943.42.547; WSHS 1943.42.1885.)

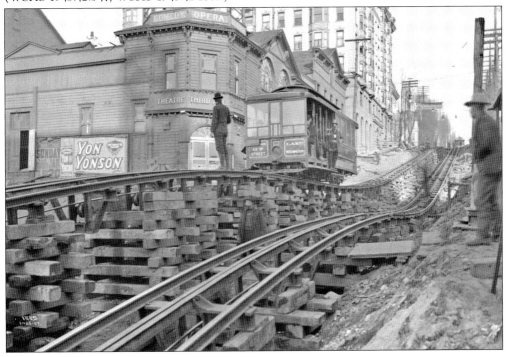

RECLAMATION TECHNIQUES AND FOOTPRINT. What was not sluiced away into the tidelands was dumped into the tidelands section by section, held in place by a series of temporary wooden structures, and covered (below). The above image shows buildings constructed on pilings over tidelands. By the end of the regrade, the elevated first floor of the buildings on pilings would become ground floor. This painstaking approach continued section by section for several decades while Seattle slowly but surely reclaimed her once-productive aquatic tidelands for upland industrial use. (WSHS 1943.42.10258; SPL 5584.)

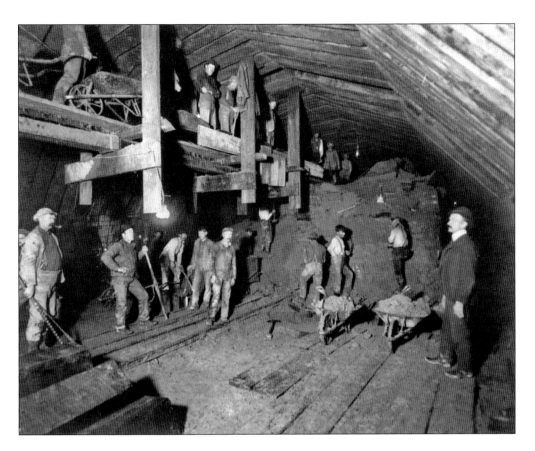

GREAT NORTHERN RAILROAD. Seattle's quest for the railroad was hard fought and bittersweet after the initial loss in 1873, when the Northern Pacific Railway sited its terminus to the south on Tacoma's Commencement Bay. City engineer Reginald Thompson heavily lobbied railroad tycoon James J. Hill to bypass the already congested Railroad Way on Seattle's waterfront. Thompson successfully convinced Hill of his idea, creating yet another underground feature, a railway tunnel under Seattle. The southern portal begins at Fourth Avenue and Washington Street in Pioneer Square (the dark circle to the right of the "OWL" building, below); the northern tunnel exits at Elliott Avenue between Stewart and Virginia Streets near the waterfront below Pike's Place Market. The image above shows the tunnel excavation with construction technology of the era: shovels, picks, and wheelbarrows, with top hats and derbies serving as personal protection equipment. (UWSC CUR337; WSHS Curtis-69/p.62.)

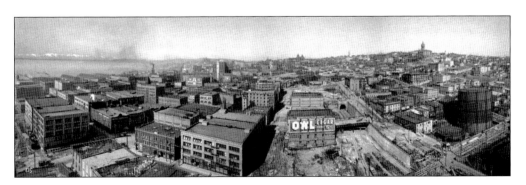

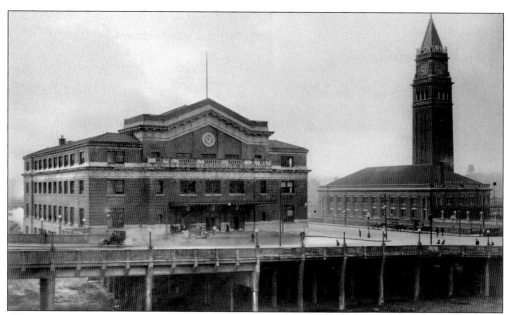

KING STREET AND UNION TRAIN STATIONS. The elevated road above the reclaimed tidelands showcases both the Oregon-Washington Station (above left, now known as Union Station) and the King Street Station (above right) on what would have been over 50 feet of water. Seattle's King Street Station was constructed between 1904 and 1906 for the Great Northern Railroad. It replaced the rundown wooden train depot on Railroad Avenue and Columbia Street (page 87). The tower of King Street Station is an exact replica of St. Mark's Campanile in Venice, Italy, supposedly to bring a touch of heritage and tradition to Seattle. Inside King Street Station (below), the decor held exquisite detail, with beautiful ceilings, balconies, lighting fixtures, and an overall Beaux Arts elegance. The Oregon-Washington Station was completed in 1911 to serve the Union Pacific Railroad and the Milwaukee Road, a subsidiary of the Union Pacific. (MOHAI 2002.48.687; MOHAI 1983.10.7583.)

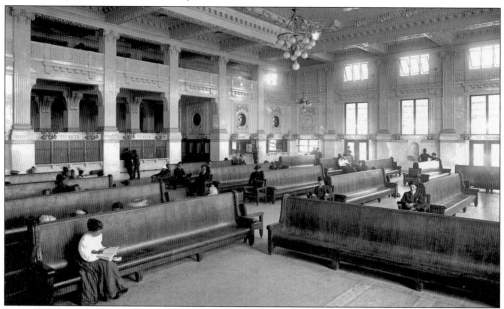

UNION WAITING ROOM AND KING STREET LADIES ROOM. Serving as the new north Pacific Coast terminal of the Union Pacific and Southern Pacific systems, the Oregon-Washington Station opened on May 20, 1911, after less than two years of construction. The interior (right) is beautifully appointed from floor to ceiling. Today it is called Union Street Station and is the headquarters for Sound Transit, a regional public transportation agency providing hard-rail, light-rail, and bus service to Pierce County, King County, and Snohomish County. This building was constructed on what were originally aquatic tidal lands reclaimed by Seattle's multiple regrades. Both Union and King Street Station provided special waiting rooms for female passengers. The image below shows the King Street Ladies Waiting Room, appointed with rocking chairs, tables, and comfortable seating in a safe, secure place with assistance for women should they need it. (MOHAI 1983.10.9334; MOHAI 1983.10.7506.)

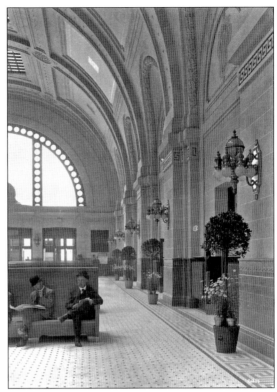

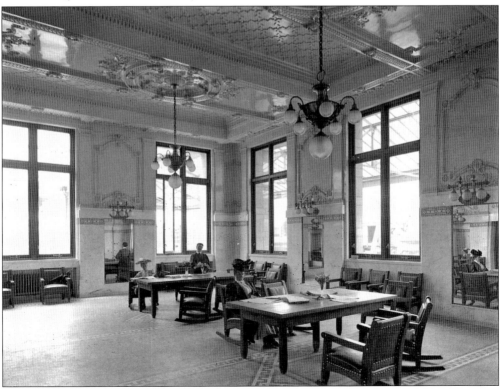

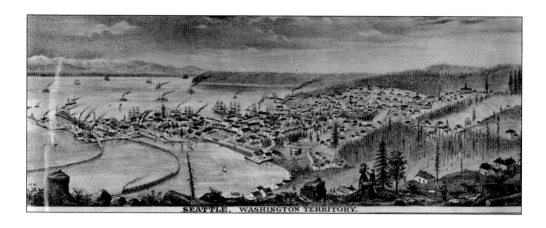

TIDELANDS: BEFORE AND AFTER. The image above shows Pioneer Square, Elliott Bay, and the tidelands in the 1880s. This contrasts with the image below of the same view in 1925. Almost everything in the lower image would have been under water in the original landscape. The habitat and species the tidelands supported are gone forever. The flat land envisioned has been achieved. Unknown to the engineers at the time, the reclaimed tidelands sit on top of the Seattle Fault, a major earthquake fault. The reclaimed tidelands and all that is built on them today are prone to liquefaction in an earthquake event, which means that the soils turn to liquid mush and can cause severe damage. (WSHS Curtis 30422; MOHAI 2002.3.341.)

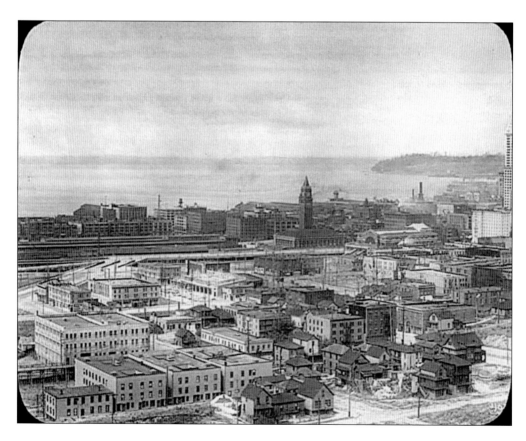

Eight

PROHIBITION, DEPRESSION, AND RENEWAL

As the population of Seattle grew, the reputation of Skid Road and Pioneer Square pushed the business district to the north and the residential population to the east. Gradually, the once-thriving Pioneer Square area became run down and derelict. The 1929 crash of the stock market further exacerbated the problem. Building owners could either not take care of their buildings or lost them altogether. The once-beautiful buildings built representing optimism after the Great Fire of 1889 fell into disrepair and were occupied by the poor and disenfranchised population of the town. Though more of an undercurrent of the area, the always-present social problems of the destitute—alcoholism, prostitution, drugs, thugs, homelessness, and mental illness—became the mainstay. The economic and social problems became so pronounced during the Depression that a Hooverville sprang up on the reclaimed land filled with people living in shanties trying to eke through the day finding scraps to eat from the garbage dump and trying to stay warm from fires fueled by driftwood.

Urban renewal initiatives of the 1960s resulted in the destruction of many of the most beautiful unique buildings to make way for parking garages and vacant lots. The destruction of the once opulent Seattle Hotel, rebuilt on the same location as the Occidental Hotel destroyed by the 1889 fire, served as the catalyst for local preservationists to create one of the first and one of the largest National Historic Districts registered in the nation, protecting over 30 acres of buildings from the wrecking ball and preserving Seattle's legacy of rich history and beauty for future generations.

Because of local activists such as Bill Speidel, founder of Seattle's Underground Tour, and Victor Steinbrueck and the leadership of Mayor Wes Uhlman, beginning in the 1970s, Seattle's Pioneer Square area has seen a gradual resurgence of art, business, entertainment, and dining. The sports venues adjacent to Pioneer Square have also brought new life to the area, along with significant refurbishing of many historic buildings in Pioneer Square that millions of visitors, workers, and Seattle residents enjoy every day.

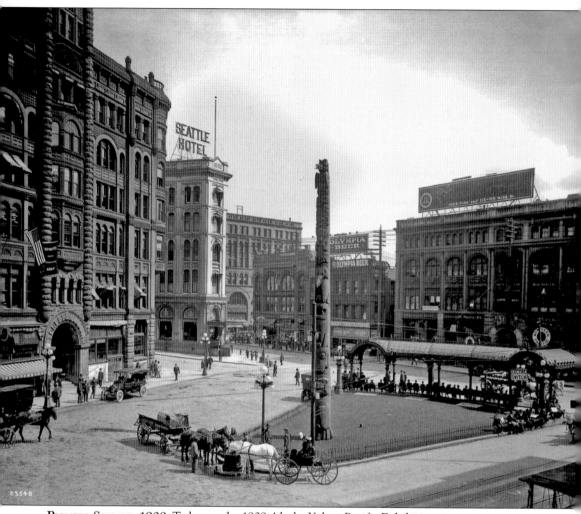

PIONEER SQUARE, 1909. To honor the 1909 Alaska-Yukon Pacific Exhibition, improvements were made to Pioneer Place that transformed this important historic public gathering spot into the icon it is today. New additions included an elegant pergola, the cast bronze Chief Seattle Water Fountain, and elaborate comfort stations. What had once been the location of Duwamish longhouses was later a plat dispute between pioneers Doc Maynard and Arthur Denny, creating a dusty or muddy wide spot in the road near Yesler's sawmill and cookhouse that saw hangings, Chinese riots, and an awkward traffic-jammed intersection. It was now a wonderful tiny triangular public park. Pioneer Place Park remains the most memorable and important historic public square in the Seattle Pioneer Square Historic Preservation District and perhaps in all of Seattle. (WSHS Curtis 2354-8.)

WATER FOUNTAIN AND PERGOLA. The Chief Seattle Water Fountain, designed by sculptor James Wehn, was originally designed for use by horses and dogs in 1909 (right). Wehn, a noted Seattle sculptor, grew up in an orphanage and was considered a protégé of Father Xavier Prefontaine, head of Seattle's first Catholic church in Pioneer Square (next to Madam Lou's Parlor, page 40). Julian Everett designed an ornate Victorian-style iron pergola as a streetcar stop (below). Considered by Seattleites to be the most lavish ornamental iron structure of its type west of the Mississippi, the pergola also served as the entrance to a comfort station in Underground Seattle. Considered by the city to be the nation's most elaborately appointed underground restroom, it featured white-tiled walls, terrazzo floor, brass fixtures, marble stalls, and shoe-shine stands. When the facility opened in 1909, it averaged 8,000 flushes each day; Sundays, when the saloons were closed, it averaged 15,000 flushes. (MOHAI 1983.10.6148; MOHAI 83.10.6145.)

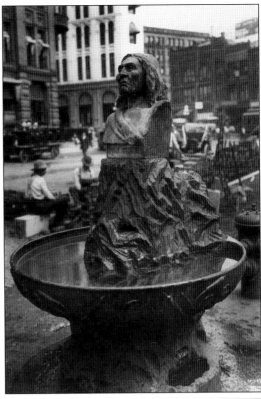

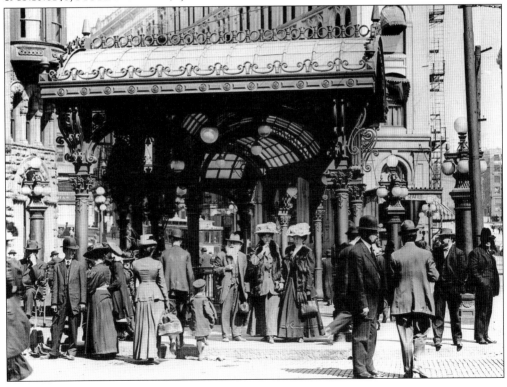

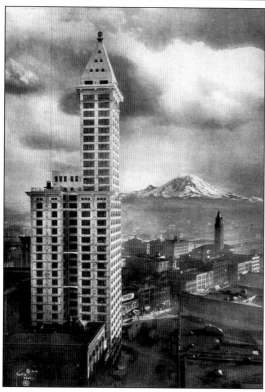

BARTELL DRUG AND SMITH TOWER.
George H. Bartell Sr. returned from the Klondike gold rush and invested in Bartell's Drug Store, still operating today as the oldest family-owned drugstore chain in the United States. Bartell opened his second store in 1908 at Second Avenue and Yesler Way (above). The second Bartell Drug was demolished to make way for the Smith Tower (left), constructed between 1911 and 1914. L. C. Smith of Smith-Corona typewriters built the Smith Tower after gaining assurances that the city government would remain in the original commercial district. Upon completion in 1914, the Smith Tower was the fourth tallest building in the world, and it was the tallest building west of the Mississippi, a title it held for 50 years. The ornate, manually operated elevators and the Chinese Room on the top floor still operate. Spectacular views of Mount Rainier, Elliott Bay, and Seattle can be seen from the upper floors of Smith Tower. (MOHAI 1983.10.7669.3; WSHS Curtis.26/1-2/44.)

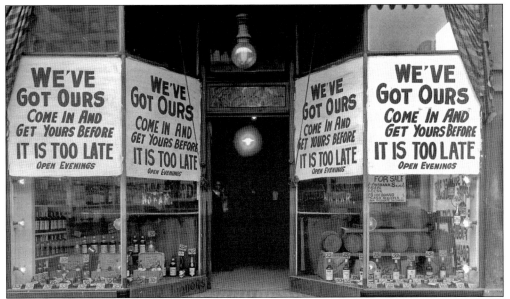

PROHIBITION. A public vote enacted statewide alcohol prohibition from 1916 to 1933. Speakeasies proliferated in Underground Seattle; areaways provided a quick getaway in case of a bust. The Pioneer Building (pages 71–72) was the clandestine location of Seattle's first speakeasy. The upscale Hotel Butler's Rose Room (page 79), another notorious speakeasy, was raided by police while the band played "How Dry I Am." Many patrons escaped through the underground areaways of the building. (MOHAI 1983.10.12279.)

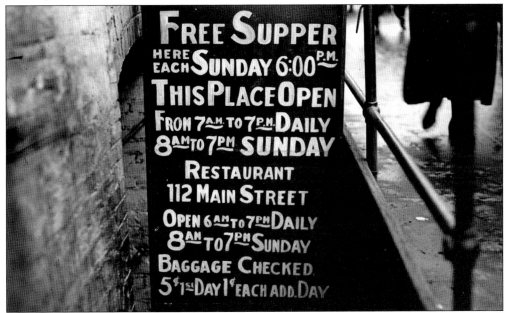

MILLIONAIR CLUB. As statewide prohibition continued and the Roaring Twenties roared on, the down-and-out continued to find their way to Pioneer Square. This 1925 sign offered a free Sunday meal provided by the Millionair Club, established in 1921 by Seattle businessman Martin Johanson to help the city's unemployed help themselves by providing meals, clothing, job training, temporary jobs, and medical referrals. (MOHAI PI22381.)

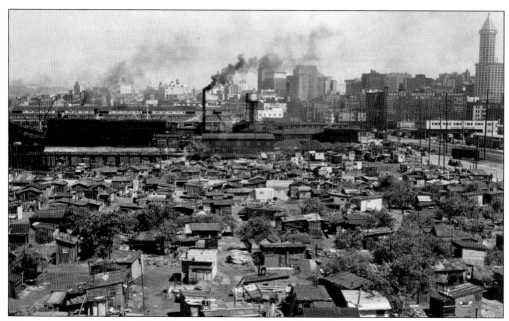

HOOVERVILLE. As the Roaring Twenties crashed into the Great Depression, a new social challenge emerged south of Skid Road: Hooverville. Named after Republican president Herbert Hoover, who opposed government assistance during the Depression, Hooverville was a shantytown for thousands trying to eke out a daily living. Residents built ramshackle homes out of scrap material and even elected their own mayor of Hooverville. The city's garbage dump, located nearby, provided a source for scavenged building materials and food. (UWSC LEE250; MOHAI 1986.5.9009.)

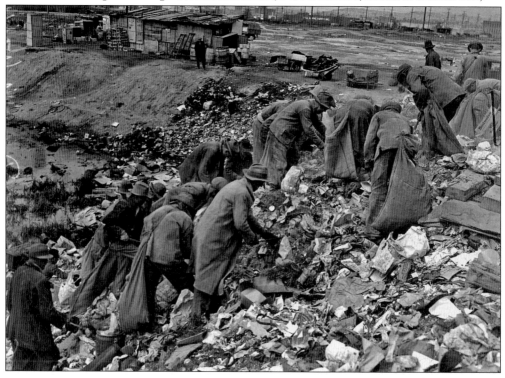

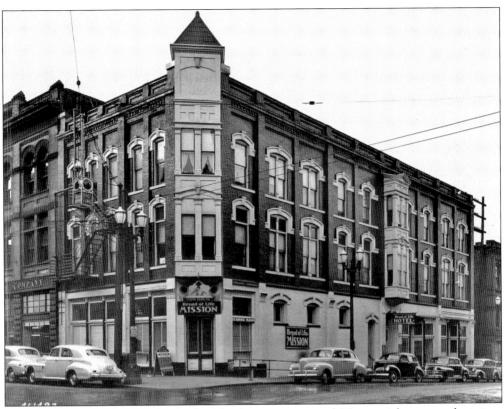

MISSIONS AND FLOPHOUSES. The needs of the destitute continued. More social groups and missions came to Pioneer Square during the Depression to help the many people in need. Above is the Bread of Life Mission founded by Mavel Sherman in 1939. The mission still serves those in need from its building at 97 South Main Street. Conditions in Pioneer Square continued to go downhill after World War II. The flophouse pictured below was a typical scene inside the many run-down buildings in Pioneer Square and provided housing to men who paid 30¢ for a bed in a poorly heated dormitory-style room. (MOHAI 1986.5.7480; MOHAI 1986.5.11829.1.)

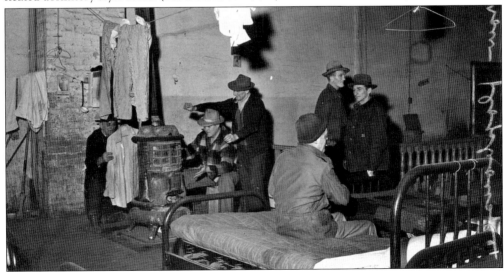

URBAN DECLINE. As the commercial business area moved north and the residential area moved east and into the suburbs, Pioneer Square continued to deteriorate. The once-opulent and upscale buildings had fallen into disrepair during the Depression and continued on the downward trend. Building occupants and clientele shifted drastically. These two images reflect the predominance of pawnshops, loan offices, taverns, low-income housing, and vacant buildings. The image above is from Second Avenue looking north from Washington Street in 1958. The lower image is on First Avenue (Front Street) looking south towards Pioneer Square in 1953. The buildings on the left were eventually destroyed for parking garages. The Lowman & Hanford buildings can be seen to the right. (MOHAI Lenggenhager 6739; MOHAI Lenggenhager 4341.)

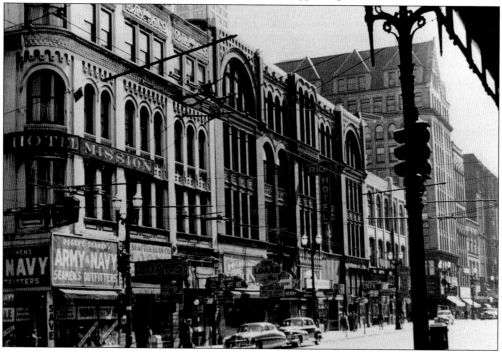

PARKING GARAGE. The downward spiral of Pioneer Square had almost hit the bottom when the historic, once-opulent Seattle Hotel (right) was torn down in 1961 to make way for a parking garage that some say resembles a sinking ship (below). The destruction of this icon served as a catalyst to unify concerned citizens to take action. Local leaders such as Victor Steinbreck, local historian Bill Speidel, and many more petitioned city hall to create a National Historic District. Seattle City Council rejected the original requests in 1969. However, Mayor Wes Uhlman was able to sign into law the City of Seattle's Pioneer Square Historic Preservation District in 1970. Controversial and fraught with lawsuits at the time, this legislation is responsible for preserving Seattle's historic Pioneer Square today and for future generations. (UWSC CFT0049; UWSC Hamilton Vol. 3.)

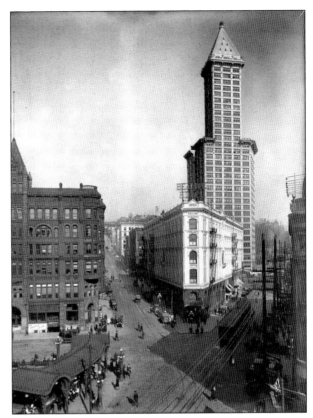

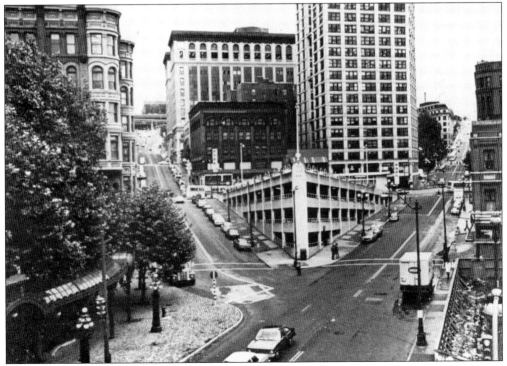

UNDERGROUND REDISCOVERED. Underground Seattle was officially closed in the late 1890s due to concerns of bubonic plague spread by fleas on rats that made their home in the areaways; it was closed again after Prohibition and almost forgotten. If not for local journalist and historian Bill Speidel, Seattle might still not remember she had an underground. Fortunately, Speidel started what was supposed to be a one-time Underground Tour in the 1960s (left), and due to keen interest, he never stopped. His daughter, Sunny Speidel, carried on the family tradition after the passing of her father in 1988. Today millions of locals and tourists make a special trek to Pioneer Square to visit and learn Seattle's historic past while experiencing Seattle's underground firsthand. (Both, Bill Speidel's Underground Tour.)

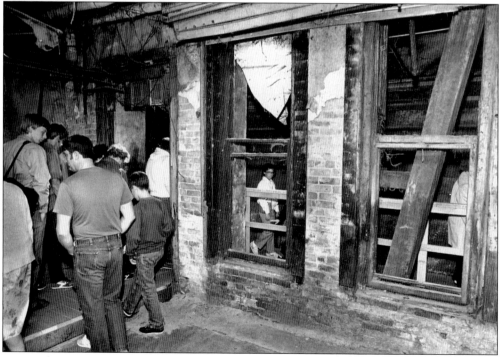

AREAWAY SKYLIGHTS. Walking on the sidewalks in Seattle's Pioneer Square, a person can see Seattle's underground from above. The thick-glass skylights (right), many original from the rebuilding of Seattle after the Great Fire of 1889, provide natural light to the underground. Once under the city, a person can see how the skylights bring light into the areaways (below). Standing in the underground areaway, imagine being in Seattle during the 1880s or before; one would have been standing at ground level, looking out at Elliott Bay. The original grade of the city was elevated between 10 and 40 feet during the rebuilding of the city after the 1889 fire to help with the plumbing and drainage problems Pioneer Square experienced from inception due to her proximity to Puget Sound's Elliott Bay. Sunny Speidel (center) is leading this tour around 1980. One hundred years earlier, Speidel would have been standing at surface level near the waterfront (page 24). (J. Keniston-Longrie; Bill Speidel's Underground Tour.)

BILL SPEIDEL'S
UNDERGROUND

INFORMATION 682-1511 • RESERVATIONS 682-4646
610 FIRST SEATTLE, WA

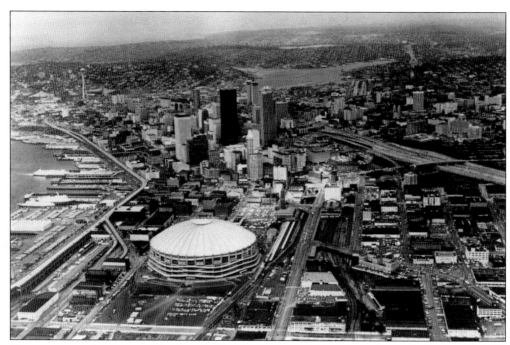

KINGDOME AND IMPLOSION. The Seattle Kingdome was an indoor sports arena built in 1972–1976 (above), despite local community protests. It operated from 1976 until its demolition via implosion in 2000 (below). It was located just south of Pioneer Square on reclaimed tidelands, on the land that was once Ballast Island (page 83) and then Hooverville (page 118). The Kingdome served as a sports venue for multiple teams: the Seattle Mariners baseball team; Seattle Seahawks football team; and the Seattle Supersonics basketball team, who occupied it for several years while Key Arena was being remodeled. The first sports game played in the Kingdome was the North American Soccer League's New York Cosmos and Seattle Sounders. Due to concrete construction materials and Seattle's noisy fans, the Kingdome was known as one of the loudest stadiums in the National Football League. (SPL 23114; Seattle Municipal Archives 100486, photograph by Ian Edelstein.)

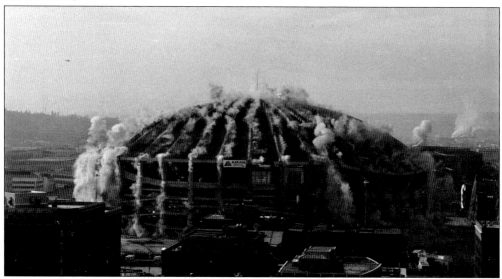

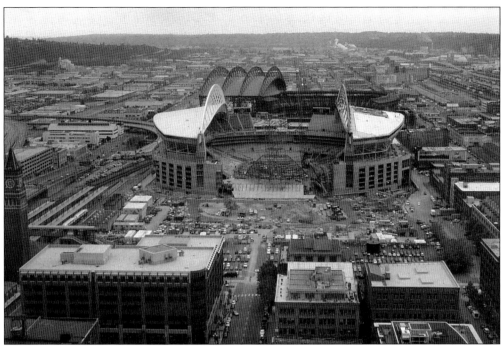

SEAHAWKS AND MARINER STADIUMS. A portion of Seattle's Pioneer Square neighborhood can be seen in the image looking south onto Seattle's two new sports arenas: the Seahawks' Qwest Field and the Mariners' Safeco Field, which has a retractable roof (above). These two sports venues are built on reclaimed tidelands. One hundred years ago, they would have been underwater in Puget Sound south of Pioneer Square. They are built in approximately the same location as the Seattle Kingdome, which was demolished to make way for these two new sports venues. Thousands of sports fans descend upon Seattle's Pioneer Square before and after the games for drinks, food, and other entertainment. The historic Triangle Building (right) is said to have been the smallest hotel on the West Coast. Originally serving workingmen, it now houses residents and a pub. It is located just west of the sports stadiums. (Seattle Municipal Archives 120336; UWSC LEE169.)

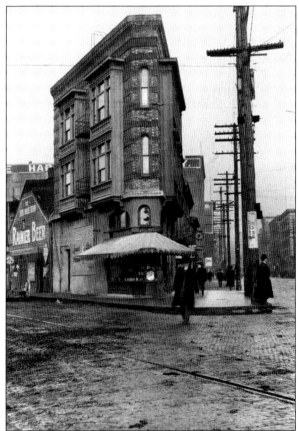

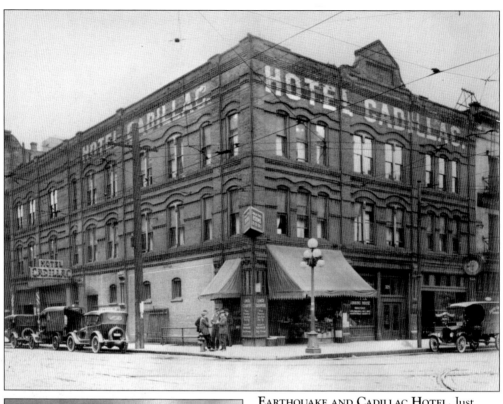

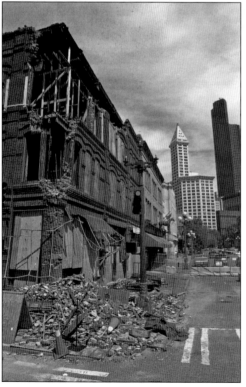

EARTHQUAKE AND CADILLAC HOTEL. Just north of the sports stadiums on Second Avenue South and Jackson Street is the historic Cadillac Hotel in Pioneer Square. Designed by a carpenter named James Houghton and a Mr. Clements, the Cadillac Hotel was built in the first six months after the Great Fire of 1889. The 56-room Cadillac Hotel (above) provided lodging for single workingmen and later lodging during the Klondike gold rush. It was severely damaged in the 6.8 Nisqually Earthquake that rocked Seattle on February 28, 2001 (left). It was considered a candidate for demolition, but locals banned together to save yet another historic building from destruction. The renovation of the Cadillac Hotel was completed in 2004, and it now houses the Klondike Gold Rush National Historic Park and National Park Service Regional Headquarters. (UWSC SEA2487; Seattle Municipal Archives 113523.)

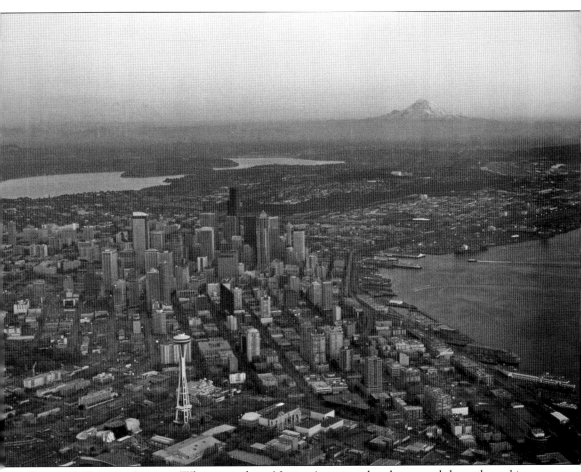

SEATTLE'S PIONEER SQUARE. What started as a Native American longhouse and then a log cabin in 1852 on a small 8-acre island, Seattle's Pioneer Square has transformed into an urban landscape that our visionary founders would find hard to believe. The towering Douglas firs and cedar forests have been replaced with towering skyscrapers. While Seattle has grown and changed over time, thanks to the foresight of recent leaders, the historic legacy built by the pioneers and founders has been saved today for future generations to enjoy, learn from, and appreciate. Preserving Seattle's historic Pioneer Square helps continue the Duwamish/Suquamish tradition of storytelling, passing ancestral lore from generation to generation. (Seattle Municipal Archives 108525, photograph by Ian Edelstein.)

ACROSS AMERICA, PEOPLE ARE DISCOVERING SOMETHING WONDERFUL. *THEIR HERITAGE.*

Arcadia Publishing is the leading local history publisher in the United States. With more than 5,000 titles in print and hundreds of new titles released every year, Arcadia has extensive specialized experience chronicling the history of communities and celebrating America's hidden stories, bringing to life the people, places, and events from the past. To discover the history of other communities across the nation, please visit:

www.arcadiapublishing.com

Customized search tools allow you to find regional history books about the town where you grew up, the cities where your friends and family live, the town where your parents met, or even that retirement spot you've been dreaming about.